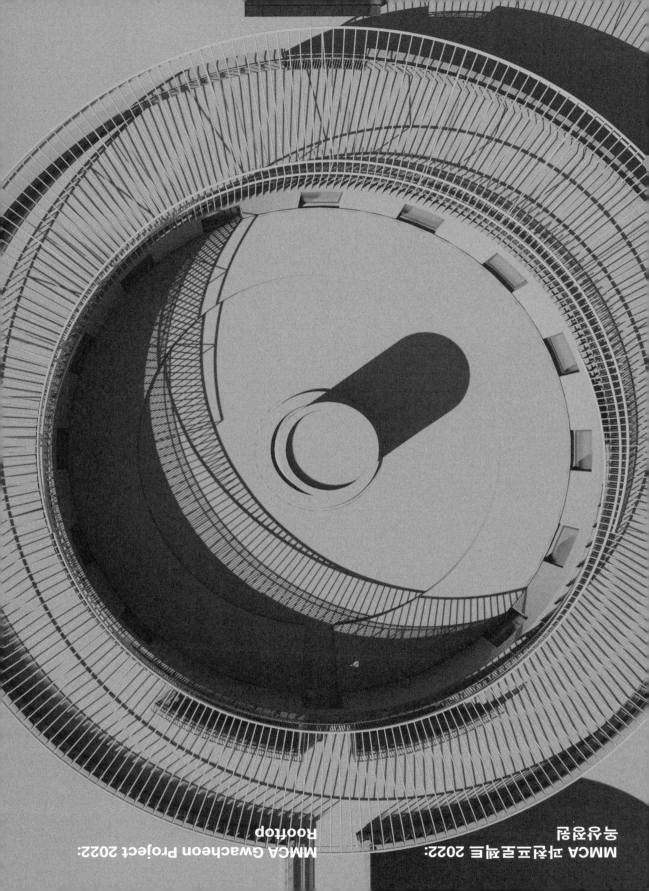

MMCA 과천프로젝트 2022:
옥상정원

MMCA Gwacheon Project 2022:
Rooftop

MMCA 과천프로젝트 2022: 옥상정원
시간의 정원
2022.6.29.–2023.6.25.

관장	윤범모
학예연구실장 직무대리	송수정
현대미술2과장	임대근
학예연구관	조장은
프로젝트 기획 및 실행	배수현
프로젝트 지원	남은혜
그래픽 디자인	이건정
프로젝트 운영	명이식
기술·시설 (건축, 전기, 조경 등)	이세진, 손새로미, 신호섭
홍보·마케팅	이성희, 윤승연, 채지연, 김홍조, 김민주, 이민지, 기성미, 신나래, 장라윤, 김보윤
고객지원	오경옥 추헌철
교정·교열	김가영
번역	서울셀렉션
영상·촬영	슈가솔트페퍼 프로덕션
협찬	S FEEL (주)에스필코리아

MMCA Gwacheon Project 2022: Rooftop Garden in Time
Jun 29, 2022 – Jun 25, 2023

Director	Youn Bummo
Supervised by	Song Sujong, Lim Daegeun, Cho Jangeun
Curated by	Bae Suhyun
Curatorial Assistant	Nam Eunhye
Graphic Design	Lee Gunjung
Technical Coordination	Myeong Yisik
Facilities Management	Lee Sejin, Son Saeromi, Shin Hoseob
Public Communication and Marketing	Lee Sunghee, Yun Tiffany, Chae Jiyeon, Kim Hongjo, Kim Minjoo, Lee Minjee, Ki Sungmi, Shin Narae, Jang Layoon, Kim Boyoon
Customer Service	Oh Kyung-ok, Chu Hunchul
Copyediting	Kim Kay
Translation	Seoul Selection
Filming·Photography	sugarsaltpepper production
Supported by	S FEEL SFEEL KOREA Co.,Ltd.

MMCA 과천프로젝트 2022:
옥상정원

MMCA Gwacheon Project 2022:
Rooftop

시간의 정원

Garden in Time

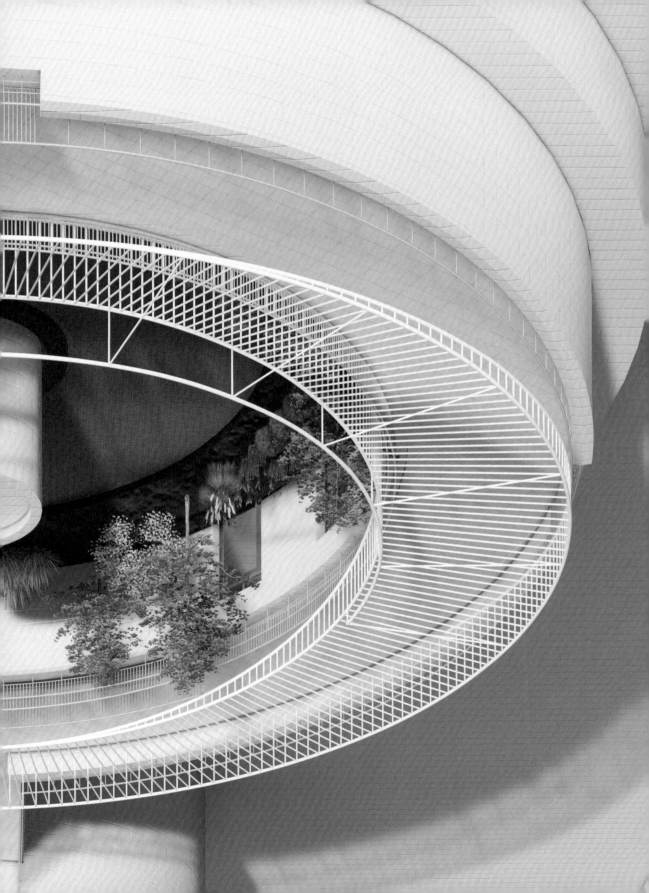

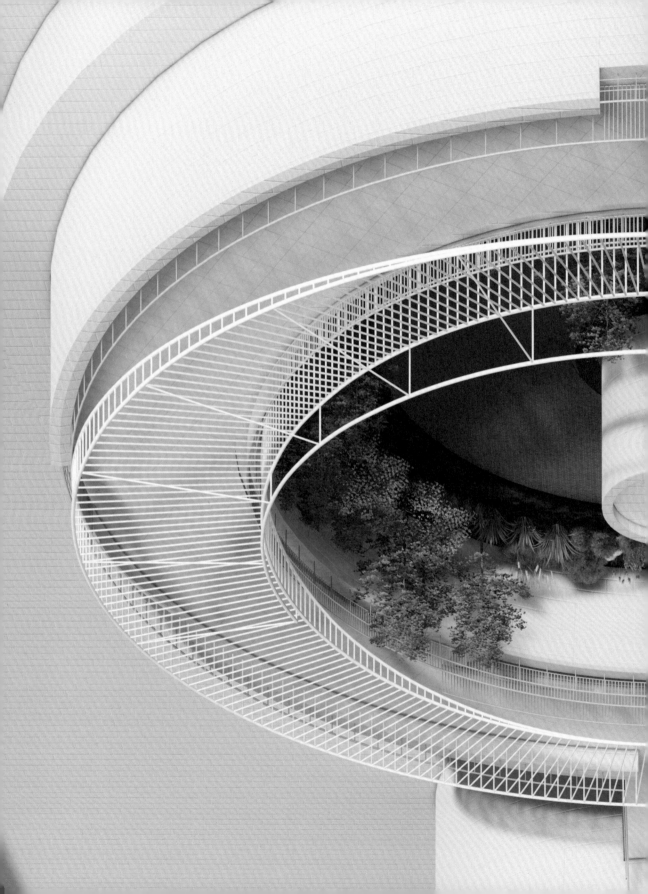

발간사

《MMCA 과천프로젝트 2022:
옥상정원》을 개최하면서

윤범모(국립현대미술관 관장)

Foreword

In Presenting
MMCA Gwacheon Project
2022: Rooftop

Youn Bummo (Director, National Museum of
Modern and Contemporary Art, Korea)

국립현대미술관 과천은 청계산, 과천 저수지 등 주변 풍광이 아름답게 어우러진 '자연 속 미술관'입니다. 1986년 개관 이래 과천관은 자연과 예술을 동시에 향유할 수 있는 장소로서 많은 이의 사랑을 받아왔습니다. 국립현대미술관은 이러한 과천관의 특수한 장소성을 살려 야외 공간을 활성화하고자 2020년부터 과천프로젝트를 추진해 왔습니다. 야외조각공원에 예술과 쉼의 공간을 마련한 《과천프로젝트 2020》에 이어 《과천프로젝트 2021》부터는 일시적인 야외 파빌리온 및 설치 프로젝트로부터 미술관 방문 및 관람 경험의 가치를 높일 수 있는 중장기 공간 재생 프로젝트로 변화를 모색하였습니다.

2021년 과천관 순환 버스 정류장을 예술·생태적으로 재편한 데 이어, 올해는 미술관 경험을 마무리하는 장소라 할 수 있는 미술관 옥상을 새롭게 재생하고자 합니다. 미술관의 가장 높은 곳에 자리한 옥상정원은 주변 자연 풍광과 야외조각공원 등을 한눈에 조망할 수 있는 명소입니다. 《MMCA 과천프로젝트 2022: 옥상정원》은 그동안 잘 알려지지 않았던 옥상정원을 관람객에게 적극 개방하여 자연을 만끽하는 독창적인 방식을 제시하고자 합니다.

《MMCA 과천프로젝트 2022: 옥상정원》의 작가 선정을 위해 공모를 추진하였고, 최종 후보군 5인(팀)은 옥상정원 공간 및 경험의 가치를 높일 수 있는 다양한 가능성을 보여주었습니다. 이 중 심사를 거쳐 이정훈(조호건축) 건축가의 〈시간의 정원〉을 선정하였습니다. 〈시간의 정원〉은 예술이 자연의 변화에 조응하는 특별한 감각의 공간을 선사할 것입니다.

과천관을 찾는 많은 분들이, 새로운 감각으로 거듭난 옥상정원에서 '자연 속 미술관'을 더욱 생생하게 느낄 수 있기를 기대합니다. 이번 프로젝트에 참여해 주신 선정 작가와 최종 후보 작가, 추천 위원 및 심사 위원, 프로젝트 관계자 여러분께 감사의 말씀 드립니다.

Surrounded by Cheonggyesan Mountain, Gwacheon Reservoir, and lush green scenery, the National Museum of Modern and Contemporary Art, Gwacheon (MMCA Gwacheon) is "a museum nestled in nature." Since opening in 1986, the museum has grown immensely popular as the optimal place for appreciating art and nature. The MMCA launched the Gwacheon Project in 2020 to fully highlight MMCA Gwacheon's site and revitalize its outdoor space. While *MMCA Gwacheon Project 2020* created a space for a leisurely artistic experience at the Outdoor Sculpture Park, its direction was shifted in 2021 from focusing on temporary outdoor pavilion and installation project to mid-to-long-term space regeneration aimed at enhancing the museum experience.

Following last year's project, which artistically and ecologically transformed the shuttlebus stops around the museum, this year's edition seeks to regenerate the museum's Rooftop, where the visitor experience can be seen to end. Situated on the topmost story, the Rooftop is a hidden attraction offering a panoramic view of the surrounding landscape and the Outdoor Sculpture Park. *MMCA Gwacheon Project 2022: Rooftop* invites visitors up to the Rooftop, a relatively under-recognized part of the museum, to propose an innovative way to fully appreciate the vast nature surrounding the museum.

The MMCA held a selective competition to select an artist for the project, and the five finalists proposed ideas to raise the value of the Rooftop and its experience. The winner was Lee Jeonghoon (JOHO Architecture), who proposed *Garden in Time*, a space for special sensory experiences where the arts respond to changes in nature.

Reborn through a novel approach, the Rooftop will offer MMCA Gwacheon visitors a more vivid experience at "a museum nestled in nature." I sincerely thank the winning artist and the four other finalists, members of the recommendation and review committees, and all involved staff.

목차

Contents

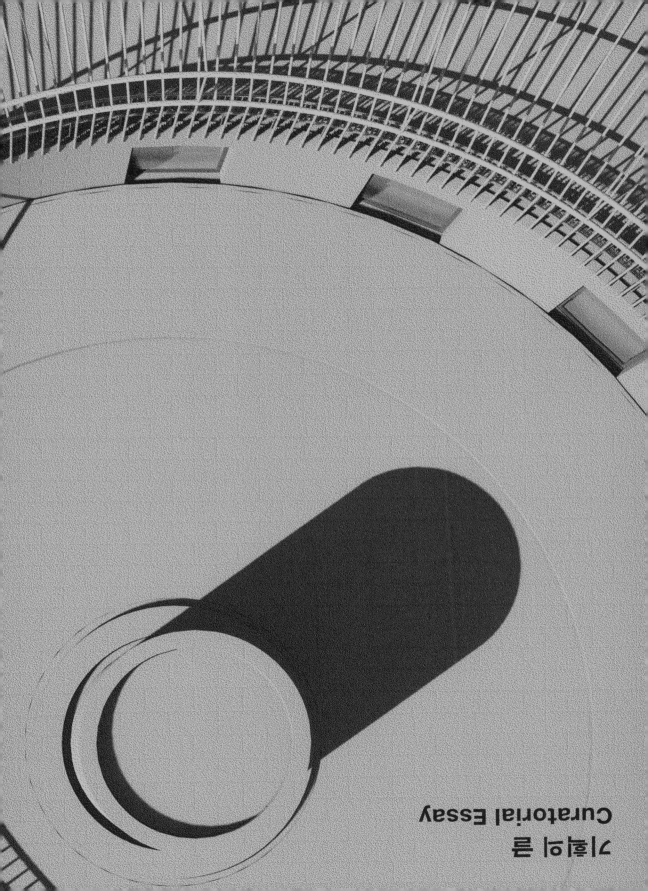

기획의 글
Curatorial Essay

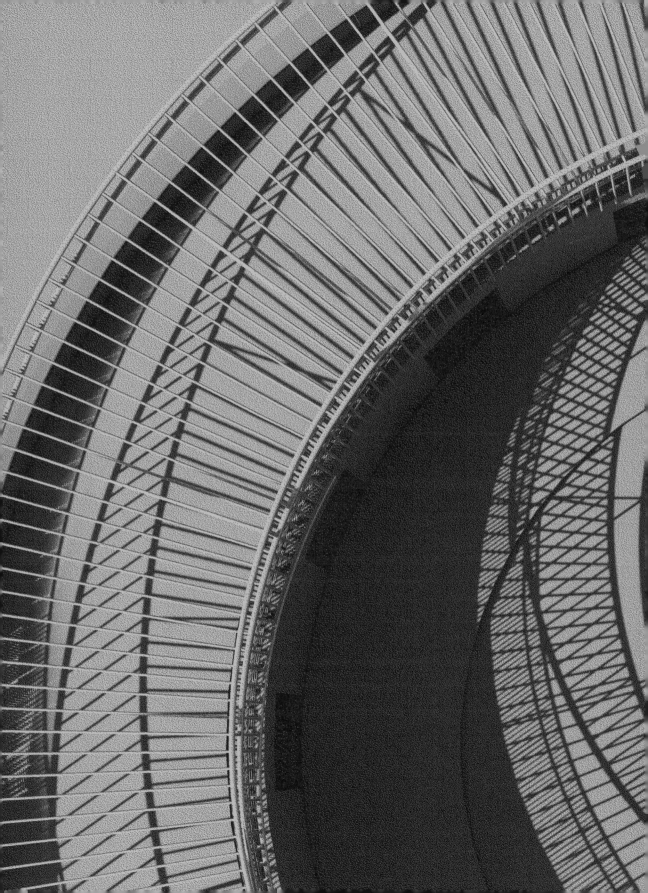

옥상정원:
장소의 회복, 경험의 완성

배수현(국립현대미술관 학예연구사)

1 "당시 한국에서 많은 새 건물들을
지으면서, 산을 깎고, 담을 싸서
건물들을 짓는 것을 보면서 안타깝게
생각하고 있었습니다. 이 거대한 만
평이 넘는 건물을 어떻게 하면 산을
해치지 않고, 산과 조화되며, (⋯)
미술관 주변 야외조각장, 휴식장을
만드는 생각들, 여러 생각이 떠올랐고,
이것들이 미술관을 설계하는 데
저의 첫 시작점이 되었습니다."
국립현대미술관,『국립현대미술관
과천 이전 20주년 기념: 건축가 김태수
초청 강연회』(과천: 국립현대미술관,
2006), 6 ; 김태수,「국립현대미술관
설계에 관하여」,『대한건축사협회』
제210권(1986): 38~40.

2 국립현대미술관,『국립현대미술관
과천 이전 20주년 기념: 건축가 김태수
초청 강연회』, 15.

3 김태수,「국립현대미술관 설계에
관하여」, 41.

MMCA 과천프로젝트는 자연 속에 자리한 국립현대미술관 과천의 특수성을
살리고, 야외 공간을 활성화하고자 기획된 공모 프로그램이다. 작년에 개최된
《MMCA 과천프로젝트 2021: 예술버스쉼터》를 기점으로 본 프로젝트는 앞서
국립현대미술관에서 선보였던 일시적인 야외 파빌리온 및 설치 프로젝트에서
미술관 방문 및 관람 경험의 가치를 높일 수 있는 중장기 공간 재생 프로젝트로
방향을 전환하였다. 과천관 순환 버스 정류장에 조성된 예술버스쉼터가 미술관
도입부에 활력을 더하였다면, 올해는 미술관 전시를 감상한 후에 다다르는
종착지이자, 과천관 최고층인 3층 옥상정원을 새로운 경험의 공간으로 재생하고자
한다.

1986년 국립현대미술관 과천 완공 이래 36년이 지난 현재,《MMCA 과천프로젝트
2022: 옥상정원》을 통해 미술관 옥상을 재편하는 것은 어떠한 의미를 지닐까?
설계자 김태수 건축가의 의도를 따라가 보면, 국립현대미술관 과천은 무엇보다
너른 대지 위에 펼쳐진 산세와 조화를 이루도록 설계되었음을 알 수 있다. 능선 위에
단과 3개의 둥근 기하학적 요소를 얹어 산과 조화를 추구한 건축물의 구조뿐만
아니라, 김태수는 미술관 진입로에서부터 건물 입구까지 걸어가는 과정에서 자연과
마주하는 공간의 경험을 중시하였다.[1] 초입의 호수와 돌다리, 층대, 정원 등으로
이어지는 시퀀스는 미술관에 이르는 길을 풍부한 감각의 전이 공간으로 만든다.

이러한 경험은 미술관에서 작품을 감상한 후 최고층인 옥상에서 절정에 이른다.
전시를 관람하고 미술관의 중심축인 중앙 홀에 이르러 백남준의 〈다다익선〉을
둘러싼 나선 램프를 오르면, 미술관 꼭대기 층에 건물 밖으로 향하는 입구가
자리한다. 좁은 오르막길을 따라 도달한 입구의 문을 나서면 탁 트인 공간,
옥상정원에 대자연이 한꺼번에 밀려든다. 자연 속에 자리한 국립현대미술관 과천의
특수성 때문에 김태수는 설계 당시부터 야외조각공원 등 외부 공간 조성에 힘썼고,[2]
특히, 옥상을 주변 전경을 한눈에 조망하며 거니는 산책 공간(promenade)으로
조성하였다.[3] 그러나 건립 당시 계획과는 달리 미술관 옥상은 그동안 관람객에게
적극적으로 개방되지 않았다. 따라서 옥상 공간을 건축가의 원의도였던 산책로이자
자연·건축·예술의 조화가 빚어내는 특별한 공간으로 재편하는 일은 옥상의 특수한
장소성을 되살림으로써 미술관 공간 경험의 시퀀스를 완성하는 작업이다.

《MMCA 과천프로젝트 2022: 옥상정원》은 미술관 옥상 공간을 예술·생태적으로
재생하여 관람객이 미술관 주변 자연을 즐기는 것은 물론, 미술관에서의 미적
경험을 야외 공간의 자연 속 다양한 감각으로 확장하는 새로운 예술적 옥상을
제시하고자 한다. 이를 위해 최종 후보군 5인(팀)에게 '쉼과 산책', '자연의 감각과
예술의 공명', '공간·경험의 연결과 확장'이라는 키워드가 주어졌다.

휴게 공간이 부족한 과천관의 실정에 따라 옥상정원은 무엇보다도 관람객이 작품
감상의 여운을 누리며 쉴 수 있는 기능을 충족하기를 기대했다. 따라서 물리적

점유와 사건이 일어나는 공간보다는 자연의 비물질적인 감각 속에서 쉴 수 있는 '비움의 공간'을 지향하였다. 이 비움의 공간에 빛, 바람 등 자연의 요소와 예술 작품이 서로 조응하는 새로운 풍경을 담고자 하였다. 나아가 향후, 사운드, 퍼포먼스, 공연 등이 펼쳐지는 예술 무대로서의 잠재적 가능성 또한 고려하였다.

한편, 옥상정원은 미술관 내외부 공간을 연결하고 확장하는 장소이다. 가장 가까운 옥상정원 중심부로는 2층에 조성된 원형정원이 한눈에 내려다보이며, 탁 트인 외곽부로는 과천의 수려한 자연 풍광이 펼쳐진다. 근경의 원형정원과 원경의 청계산과 호수를 연결하고 아우르는 개념적 의미의 정원이라 할 수 있다. 또한, 이곳은 미술관 내부 전시실, 〈다다익선〉이 설치된 중앙 홀로부터 야외 공간을 잇는 연결부로서 미술관의 미적 경험을 야외의 자연 풍경과 감각으로 확장한다. 나아가, 서울대공원에서도 눈에 띄기 때문에 미술관을 드넓은 서울대공원 일대로 연결하는 상징성을 지닌다. 따라서 새롭게 재편된 옥상정원이 미술관 건축의 미감과 조화를 이루며 주변 자연 풍광을 잇는 연결과 확장의 플랫폼이 되기를 기대했다.

최종후보군 5인(팀)과 이들이 제안한 작품은 김이홍(김이홍 아키텍츠)의 〈정형의 변형〉, 박수정, 심희준(건축공방)의 〈과천오름〉, 박희찬(스튜디오 히치)의 〈돌의 부활〉, 이석우(SWNA)의 〈생각의 대기〉, 이정훈(조호건축)의 〈시간의 정원〉이다. 이들은 옥상정원의 장소 및 역사적 맥락, 직관적 경험의 측면 등 다양한 접근 방식으로 옥상정원을 재해석하여 새로운 경험의 장소로 제안하였다.

김이홍(김이홍 아키텍츠)은 미술관 건물의 유기적인 시퀀스와 관람자의 이동성에 주목하였다. 각 전시실을 수직·수평으로 연결하는 원형 홀, 로툰다(rotunda)는 미술관의 유기적인 이동 축이다. 작가는 로툰다의 나선 램프를 따라 형성되는 원형의 동선을 옥상정원으로 연결하여 〈정형의 변형〉 경사로 위로 확장하였고, 그 흐름이 원형정원과도 연결되도록 경사로 입구를 2,3층 연결 계단으로 향하게 하였다. 동시에 수직, 수평, 원기둥 등 정형적인 기하학 구조로 구성된 건물에 축을 비튼 원형 경사로를 개입하여 변형을 통한 에너지를 생성하고자 하였다. 〈정형의 변형〉은 옥상정원을 건물의 연속선상에서 재배치하고 이동의 감각을 활성화하여 공간을 역동적으로 변화시킨다.

박수정, 심희준(건축공방)은 관람자의 개입으로 완성되는 작품을 제안하였다. 작품이 지닌 세 다른 층위의 높이는 평상에 눕거나 앉는 행위뿐 아니라 걸어서 전망대에 오르는 행위를 유도한다. 동시에 난간의 가림 없이 풍광을 조망하는 기회를 마련하여 옥상정원의 자연을 온전히 경험하게 한다. 움직이는 관람자의 행위는 〈과천오름〉의 주요 풍경으로 작동하며, 대공원역에서부터 국립현대미술관 과천 옥상정원에 이르기까지 지속되는 '오르는 행위'를 함축한다. 또한, 작가는 가벼운 구조체, 파란 하늘을 응축한 색상, 밤의 별과 같은 조명 등으로 작품 자체에 자연을 투영하고자 하였다.

박희찬(스튜디오 히치)은 자연 풍광에 오롯이 집중할 수 있도록, 이를 간섭하는 시각적 요소들을 비워내고 본질서에 따라 재편함으로써 공간을 새롭게 탈바꿈하는 재생 전략을 내세운다. 이러한 과정에서 미술관 건물의 역사적 맥락에 접근하는데, 준공 시 원설계와 달리 옥상 바닥에 원형의 흐름에 상응하지 않는 60×60cm의 사각형 돌이 격자로 배치된 것에 주목한다. 작가는 1986년 김태수 건축가의 의도를 2022년의 기술을 활용하여 되살림으로써 미술관 옥상의 공간 경험을 완성하고자 한다. 사각형 돌에 원형의 질서를 따르는 패턴을 상감 형식으로 새겨 넣고, 바닥 패턴에 조응하는 트렌치와 난간을 디자인하여 공간의 질서를 회복하고자 하였다. 기존의 돌을 변형하여 재배치하는 이러한 방식은 폐기물을 발생시키지 않는 생태적 태도를 보여준다.

이석우(SWNA)는 산업디자이너로서 영감을 직관적으로 시각화하는 또 다른 접근 방식을 보여준다. 작가는 자신의 경험에 비추어 옥상정원을 미술관 전시를 감상한 후 생각이 전이되는 사유의 공간으로 제시한다. 사방이 열린 공간에서 느껴지는 해방감은 발상을 자유롭게 하고, 작품 감상 후 지속되는 여운과 사색을 누리게 한다. 작가는 번뜩이며 떠오르는 단상들을 스쳐 지나가는 바람에 은유하여, 바람에 담긴 대기와 빛, 자연의 감각을 시각화하였다. 자유로운 곡선과 스테인리스 소재를 사용하여, 주변 자연 풍광을 작품이라는 매개체를 거쳐 새롭게 바라보게 하는 흥미로운 지점을 선사한다.

선정작 이정훈(조호건축)의 〈시간의 정원〉은 자연과 예술적 시공간이 조화를 이루며, 미술관 관람 경험의 가치를 높일 수 있다는 점에서 높은 평가를 받았다. 〈시간의 정원〉은 열린 캐노피 구조로 직경 39m의 대형 설치작품이다. 지붕과 옆면의 경계에 위치한 4개의 원형 링이 서로 다른 각도로 교차하며, 옥상정원 외곽 쪽은 입구에서 멀어질수록 자연 풍광이 오롯이 드러난다. 일정 간격으로 늘어선 수많은 파이프의 배열은 공간에 리듬감을 더하며, 점점 높아지고 커지는 구조물의 공간감을 따라 관람객을 가장 아름다운 풍광이 펼쳐지는 곳으로 이끈다. 이곳까지 걸어가는 과정에서 관람객은 다양한 조각적 풍경을 마주하게 된다. 〈시간의 정원〉은 과천관을 둘러싼 드넓은 자연을 더욱 극적으로 감상할 수 있도록 관람객의 시야를 조율하는 시각적 장치로 작동한다. 또한, 이를 극대화하고자 풍광이 전면 개방되는 부분은 지붕을 받치는 기둥을 설치하지 않는 캔틸레버 구조로 공학적인 실험성을 발휘하였다.

계절과 날씨에 따라 작품에 투영되는 빛과 그림자의 변화는 '자연의 순환', '순간의 연속성', '시간의 흐름' 등을 시각화하며 자연의 감각과 예술이 공명하는 시공간을 펼쳐낸다. 작가는 최소한의 물리적 구조물로써 비물질적인 자연의 감각을 현현하는 방식으로 공간을 새롭게 빚어낸다. 자연을 눈으로 감상하는 것에서 나아가, 빛, 바람 등 공감각적 경험을 통해 입체적으로 감상할 수 있는 새로운 방식을 제시한다. 이-푸 투안(Yi-Fu Tuan)에 따르면 건축 공간은 인간의 감정 리듬을 반영할 수 있다는

측면에서 "얼어붙은 음악, 즉 공간화된 시간(spatialized time)"이라고 불린다.[4] 〈시간의 정원〉은 빛, 그림자, 바람 등 공감각적 요소의 변화가 작품 및 관람자와 조우하여 만들어내는 다채로운 리듬이 실린 "공간화된 시간"이자 시간을 품은 공간이라 할 수 있다.

이곳에는 공간을 걸어 다니는 관람자의 행위의 시간도 더해진다. 이러한 상호 작용을 통해 관람자의 신체에 공간에 대한 감각이 새겨지면서, 옥상정원은 의미와 가치를 지닌 경험의 장소로 변모한다. 이는 미술관 공간 전반 경험의 연결선상에 있다. 미술관 초입부에서 입구까지 이르는 길의 감각, 작품 감상 후의 여운, 좁은 나선형의 램프 길을 돌아 마주하는 탁 트인 전경의 느낌 등이 옥상정원을 거니는 동안 총체적으로 어우러져, 미술관 공간 경험의 절정에 이르게 한다. 미술관에 머물렀던 시간의 층위가 쌓이고, 장소의 경험이 겹쳐지는 것이다.

한편, 작품에 영감이 된 난간을 살펴보면, 90cm 높이 난간에 안전 법규 강화에 따라 1.2m 높이의 난간이 덧대어지고, 다시 그 위에서 〈시간의 정원〉 구조물이 시작된다. 작가는 기존의 것을 없애고 대체하는 방식이 아닌, 건축물의 역사적 흔적을 그대로 둔 채 창조적 시각을 덧입히는 공간 재생의 방향성을 보여준다.

국립현대미술관 과천은 1986년 개관 후 그동안 개최된 전시의 역사만큼 수많은 세월을 지나왔다. 그동안 미술관 공간은 실사용자가 어떻게 활용하느냐에 따라 설계 의도와 달리 쓰임새가 변모하였고, 더욱 활성화되거나 유휴 공간으로 전락하기도 하였다. 특히, 오늘날 미술관은 전시, 소장, 교육 등 핵심 역할 외에도 휴식과 체험을 즐기는 복합 문화 공간으로서의 기능도 요구된다. 변화하는 시대의 요청과 미술관 직원 및 관람객 등 사용자의 필요에 따라 30년이 넘은 미술관의 공간 재생은 필수적이다. 따라서 2021년에는 2층 야외 공간을 과천 주변 생태계가 펼쳐지는 원형정원으로, 2층 외곽부 실내에 조각 전시장으로 설계된 제2원형전시실은 동그라미 쉼터로 그 용도를 변경하여 이러한 필요에 부응하고자 하였다. 옥상정원은 2층의 상부로서 미술관에 부족한 휴게 공간을 확충할 뿐 아니라, 인접 공간을 유기적으로 연결하며, 원형정원 프로젝트가 선보였던 자연과 조응하는 예술적 시도를 확장한다.

과천관 공간 재생의 일환으로 기획된 《MMCA 과천프로젝트 2022: 옥상정원》은 비물질적인 자연의 감각을 환기함으로써 옥상 공간을 단순히 휴식을 취하는 공간의 기능을 넘어서 자연과 예술이 공명하는 특별한 경험의 장소로 만들고자 하였다. 〈시간의 정원〉 작품을 통해 그동안 관람객의 발길이 닿기 어려웠던 숨은 명소가 '자연 속 미술관'으로서 과천관의 정체성을 극명하게 반영하는 새로운 시공간으로 활력을 찾기를 바란다. 이번 프로젝트뿐 아니라 앞으로도 2026년에 40주년을 맞이하는 과천관 곳곳을 다양한 분야의 예술가들과 협업하여 순차적으로 재생하고 의미 있는 장소로 회복하고자 한다. 해를 거듭하는 과천프로젝트를 통해

4 이-푸 투안, 『공간과 장소』, 윤영호, 김미선 옮김(서울: 사이, 2021), 299~300. 요한 볼프강 폰 괴테(Johann Wolfgang von Goethe, 1749-1832)가 건축을 얼어붙은 음악에 비유한 것을 일컫는다.

다양한 장르의 공간 재현 방식에 틈입하는 장이 펼쳐지기를 기대한다. 나아가
이러한 노력이 언젠가 미술관을 환영이 꿈틀 고일 수 있는, '공간지도 사이' 미궁적으로
이어지는 길이 되기를 바란다.

Rooftop: Restoration of a Place, Completion of an Experience

Bae Suhyun (Curator, National Museum of Modern and Contemporary Art, Korea)

1 "Many new buildings went up in Korea at the time, and I felt sad, watching mountains being cut down and the buildings being encased in walls. I thought about how this huge, over-33,000-square-meter building could be built without harming the mountain—how it could harmonize with the mountain, (...) I had many ideas including setting up the Outdoor Sculpture Park and rest areas, which were the beginning of the museum design process." MMCA, *The 20th Anniversary of MMCA Gwacheon: Invitational Lecture by Architect Kim Tai Soo* (Gwacheon: MMCA, 2006), 6; Kim, Tai Soo, "On the Design of the MMCA," *History of Architecture* vol. 210 (1986): 38–40.

2 MMCA, *The 20th Anniversary of MMCA Gwacheon: Invitational Lecture by Architect Kim Tai Soo*, 15.

3 Kim, "On the Design of the MMCA," 41.

The MMCA Gwacheon Project is dedicated to highlighting the specificity of National Museum of Modern and Contemporary Art, Gwacheon (MMCA Gwacheon)'s location amid nature and revitalizing the museum's outdoor space. Since last year's edition, *MMCA Gwacheon Project 2021: Art Bus Shelter*, the project has evolved from a temporary outdoor pavilion installation project into a mid-to-long-term space regeneration project to enhance the value of the museum experience. Considering the new life infused into the museum's entrance during last year's project to install Art Bus Shelters at the museum's shuttle bus stops, this year's edition seeks to regenerate the Rooftop, the third and topmost floor of the museum reached by visitors at the end of the exhibition, into a novel experiential space.

So what significance does *MMCA Gwacheon Project 2022: Rooftop*, which seeks regeneration of the Rooftop, hold 36 years after MMCA Gwacheon's opening in 1986? Going back to architect Kim Tai Soo's initial blueprint, the museum was designed to prioritize harmony with the mountainscape across the wide-open land. Kim emphasized not only the architectural structure of the building—a tier and three cylindrical structures placed along the mountain ridge to blend into the landscape—but also the nature experienced throughout the journey from the museum entrance to the building.[1] The sequence from the lake and stone bridge to the steps and garden makes the approach to the museum a transitional journey filled with sumptuous senses.

The journey reaches its peak at the Rooftop, the top floor that visitors reach after viewing the museum exhibition. After looking around galleries and the Main Hall comprising the central axis of the museum, visitors travel up the spiral ramp around Paik Nam June's *The More, The Better* to reach a door on the third floor that leads outside. And as soon as they exit through this door at the end of the narrow, uphill ramp, the open space of the Rooftop and vast natural landscape rush into view all at once. With the specificity of MMCA Gwacheon's location amid nature in mind, Kim paid extra attention to the museum's outdoor space in his design, including the Outdoor Sculpture Park[2], and envisioned the Rooftop as a promenade where the surrounding scenery could be appreciated.[3] Contrary to this plan, however, the Rooftop has never actively been utilized in a way that attracts the public, which is why its renewal into a promenade as intended by Kim, and furthermore, into a remarkable space that melds nature, architecture, and art is an attempt at reviving the placeness unique to the Rooftop and thereby completing the experiential sequence of the museum space.

Thus this year's MMCA Gwacheon Project seeks to artistically and ecologically regenerate the Rooftop not only to enable visitors to view

the surrounding nature but also reintroduce the space as a means to extend the artistic experience from the interior to the outdoor space through a multisensory experience of nature. To this end, five candidate groups were selected to design the top floor through deliberation under the themes "A Leisurely Promenade," "Sensory Experience of Nature and Co-resonance of Art" and "Connection and Expansion of Space and Experience."

The plan was to have the new Rooftop as a rest area, something the museum lacks, and allow visitors to leisurely ruminate on their lingering impressions of the works in the exhibition. Thus the top floor was needed to allow visitors to empty their minds through the immaterial senses offered by nature, rather than be a space physically occupied by objects or events. And this "emptying space" would accommodate a new landscape in which natural elements such as light and wind could interact with a work of art. Moreover, the space needed the potential to be an artistic platform for sound art or performances.

From another perspective, the Rooftop connects the interior and exterior of the museum. Inside, the opening in the Rooftop's middle directly overlooks the Circular Garden on the second floor, while Gwacheon's lush natural scenery unfolds beyond the outer railing. Hence, the Rooftop conceptually can be seen to bridge and amalgamate the close-range view of the Circular Garden and the distant view of Cheonggyesan Mountain and Gwacheon Reservoir. It can also connect the indoor space—the galleries and the Main Hall centering around the work *The More, The Better*—to the outdoor space and expand on the artistic experience within the museum through a sensory experience of the outside environment. And because the Rooftop is also visible from Seoul Grand Park, it also symbolizes the connection between the museum and expansive park. In this sense, the regenerated Rooftop is seen as a platform for connection and expansion that harmonizes with the museum's architectural aesthetic and extends into the surrounding natural scenery.

The five selected candidate groups and their proposals were: Kim Leehong (Leehong Kim Architects) for *Tweaking Symmetry*; Park Su-Jeong & Sim Hee-Jun (ArchiWorkshop) for *Gwacheon OREUM*; Park Heechan (Studio Heech) for *Stone Resurrection*; Lee Sukwoo (SWNA) for *Atmosphere in Thought*; and Lee Jeonghoon (JOHO Architecture) for *Garden in Time*. These five gave their envisioned interpretations of MMCA Gwacheon's Rooftop through several approaches to explore the placeness, historical context, and intuitive experience of the space and regenerate it into one offering a novel experience.

Kim Leehong (Leehong Kim Architects) focused on the organic sequence of the museum building and the movement of the visitors through the museum. The rotunda, which vertically and horizontally connects the galleries on several floors, serves as the axis of the visitors' organic movement through the museum. The architect extended the circular course of movement through the spiral ramp inside the rotunda to the Rooftop by adding a ramp that "tweaks the symmetry" and is connected to the stairs between the second and third floors to guide the traffic to the Circular Garden. At the same time, he sought to imbue transformational energy by inserting a circular ramp that tweaks the axis of the museum building, a structure embodying geometric elements such as vertical and horizontal lines and cylinders. *Tweaking Symmetry* rearranges the Rooftop within the continuum of the museum's architectural structure and evokes a sense of travel to dynamically transform the space.

Park Su-Jeong & Sim Hee-Jun (ArchiWorkshop) submitted their plan for *Gwacheon OREUM*, which from their perspective was completed through viewer intervention. The three levels of their proposed pavilion encouraged visitors not only to sit or lie on flat surfaces but also walk up to the observatory at the top. The structure also offered a scenic view of Gwacheon without a railing to block it and maximize the visitor experience of the natural scenery on the Rooftop. The physical movement of visitors was the main sight of *Gwacheon OREUM*, which emphasized the act of "ascension" from Seoul Grand Park Station to the Rooftop. And through the use of lightweight materials, colors reminiscent of the blue sky, and lighting inspired by stars in the night sky, both architects sought to directly project nature onto their work.

Park Heechan's (Studio Heech) strategy for regenerating and transforming the Rooftop was to remove visual elements hindering full focus on the natural scenery and reorganize the space according to its architectural order. In doing so, he delved into the historical context under which the museum was built and noticed that the Rooftop was paved with 60-square-centimeter tiles in grid format, something that did not correspond to the original circular design. He sought to complete the experience of the museum's top floor by reviving the space as originally intended by architect Kim Tai Soo in 1986 using technologies available in 2022. Park proposed engraving the tiles with circular patterns and redesigning the trench and railing in a corresponding manner to restore order to the space. This plan to modify and rearrange marble tiles to prevent waste showed his eco-friendly attitude.

As an industrial designer, Lee Sukwoo (SWNA) demonstrated an intuitive approach to visualizing inspiration. Based on his experience,

he reimagined the Rooftop as a meditative space allowing metastasis of lingering thoughts from the museum exhibition. The sense of freedom felt in the open space would liberate the mind to help visitors ruminate on and savor their impressions of the works they saw. Employing the motif of wind as a metaphor for fleeting thoughts and ideas, Lee visualized the atmosphere, light, and elements of nature that wind carries. Incorporating free curves and stainless steel, his work proposed to mediate renewed perception of the landscape surrounding the museum.

Finally, the winning work *Garden in Time* by Lee Jeonghoon (JOHO Architecture) was praised for the harmony it created between natural and artistic spacetime and its elevation of the museum experience. The large-scale installation took the form of an open canopy with a 39-meter diameter. The design had four rings propped up on the side of the roof intersecting at a number of angles to gradually show the panoramic view of the natural landscape as visitors walk further away from the Rooftop entrance. The numerous pipes arranged at regular intervals add a sense of rhythm to the space, while the elevating and growing structure guides visitors to a vantage point with spectacular scenery. And by walking toward this point, visitors encounter versatile sculptural landscapes. *Garden in Time* is a visual apparatus that controls the field of view of visitors to present a dramatic view of the vast nature around the museum. To maximize this effect and demonstrate experimental engineering, the installation was designed in a cantilever structure with no pillars supporting the open vantage point.

The changes in the light and shadows cast by the work, which reflect shifts of seasons and weather, illustrate the "cycles of nature," "continuum of moments," and "passing of time" as they manifest in spacetime in which natural sensitivity and art co-resonate. Lee Jeonghoon sought to reshape the space through a minimal physical structure highlighting the immaterial senses conjured by nature, proposing a new and multidimensional mode of appreciating nature on beyond visual observation through a synesthetic experience of light and wind. According to Yi-Fu Tuan, architectural spaces are "frozen music" or "spatialized time" in that they reflect the rhythm of human emotions.[4] In this sense, *Garden in Time* can be considered "spatialized time," or a time-infused space encompassing the colorful rhythm created by interactions among the work, spectators, and synesthetic elements such as light, shadow, and wind.

The space also contains time spent by spectators walking around the Rooftop. Through this interaction, the sensory experience is physically engraved on them to gradually transform the Rooftop into an interactive venue of experience and value to expand the overall

4 Yi-Fu Tuan, *Space and Place*, trans. Yun Yeongho and Kim Miseon (Seoul: Sai, 2021), 299–300. Johann Wolfgang von Goethe (1749–1832) likened architecture to "frozen music."

시간의 정원
Garden in Time

museum experience. The journey from the entrance to the museum, resonance of works in the exhibition, and panoramic view at the end of the walk up the narrow spiral ramp all add up during the stroll around the Rooftop. The experience reaches its climax as the time spent at the museum and experience are layered and compiled.

Observing the railing around the Rooftop that inspired this work, a 1.2-meter-tall handrail was added to a 90-centimeter-tall elevation due to safety regulations, and it is from this additional handrail that the installation *Garden in Time* extends out. Rather than removing or replacing the existing railing, Lee chose to leave a trace of the historical building intact and overlay it with a creative perspective, which attests to how he approaches space regeneration.

Since its opening in 1986, MMCA Gwacheon has seen a period as eclectic as the exhibitions it has hosted. Over the years, the museum space has been utilized in ways that deviate from the original designer's plans to suit user motives, at times taking on more vitality or becoming reduced to an idle space. Today, the public expects the museum to serve as a cultural multiplex for leisure and experience in going beyond an institution for exhibitions, art collections, and education. To meet the demands of the changing times and needs of museum staff and visitors, regeneration of the nearly 30-year-old building is essential. In 2021, the outdoor space on the second floor was transformed into the Circular Garden to house samples of Gwacheon's ecosystem. And the Circular Gallery 2—the outer display area for indoor sculptures on the second floor—was turned into the Rooftop Lounge in response to such demand. The renewed Rooftop, an upward extension of the second floor's transformation, marks an expansion of the museum's inadequate communal space while organically linking its adjacent spaces. Thus this year's Gwacheon project seeks to expand on the Circular Garden's artistic attempt at melding art and nature.

Devised as part of MMCA Gwacheon's space renewal project, *Garden in Time* uses immaterial elements of nature to turn the Rooftop into a space for a specialized experience beyond mere leisure where nature and art co-resonate. The museum hopes that through *Garden in Time*, the Rooftop, an attraction largely unknown to the public, will find new life as a time-infused space that lucidly represents the museum's identity. The MMCA Gwacheon Project will continue to work with artists in a range of fields to restore and breathe new meaning into the museum's sections ahead of its 40th anniversary in 2026. Another hope is that this project leads to the rise of new platforms for discussing approaches to space regeneration and helping transform MMCA Gwacheon into a "museum as a commons" enjoyed by all.

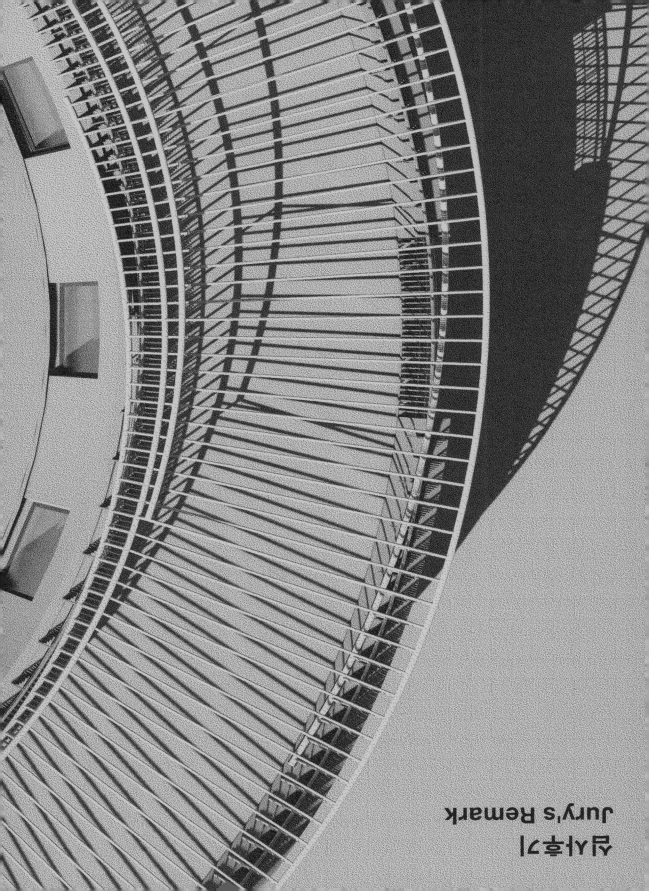

심사평기
Jury's Remark

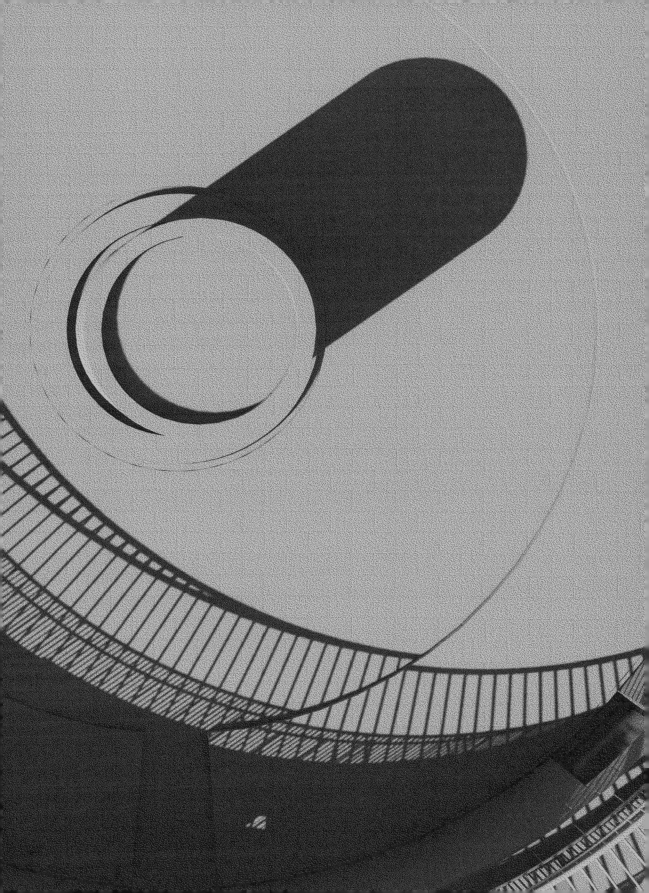

건축물에 냉난방, 환기, 통신 등등 다양한 시스템이 설계 초기 단계부터 검토되지 않은 일반 근린 생활 시설들의 경우, 옥상은 추가되는 시스템을 담을 수 있는 유일하게 남은 공간으로 오랫동안 불편하게 활용되어 왔다. 많은 기계 장비의 옥상 적체로 그동안 우리에게 옥상은 왠지 정리되지 않고 알 수 없는 위험이 내재된 공간으로 인식되었고, 실질적인 삶에서 분리되었다.

서양의 루프톱과 같은 개념은 사실상 우리에게 생경한 동경의 대상이었다. 어찌 보면 최근에, 가장 낙후된 상황을 보여주던 해방촌이 남산 자락의 경사지로 인해 형성되는 시각적 개방감을 이용해 건물의 옥상을 카페나 레스토랑 등 상업 시설로 치환한 도시적 상황은 많은 대중의 인식을 변화시켰다. 그야말로 해방촌 옥상은 핫 플레이스가 되었으며, 매우 불편하고 좁은 계단을 이용해 누구나 옥상으로 올라가 차 한 잔을 즐기려 줄을 서고 사진을 찍는 모습은 더 이상 생경하지 않다.

건물 옥상은 이제 루프톱의 가능성으로 재조명받게 되었으며, 이는 곧 버려진 공간의 재발견이자 나아가 '새로운 풍경의 발견'으로 이어졌다. 시원한 창을 통해 바깥 풍경을 실내에서 시각적으로만 확인하는 방식이 아닌, 바람을 피부로 느끼며, 외부의 소리를 듣고, 흐르는 공기의 냄새를 맡는 공감각적 체험이야말로 도심 속 자연을 경험하는 새로운 방식임을 인지하게 된 것이다. 자동차가 아닌 자전거를 타면서 온몸으로 경험하는 풍경이 주는 생동감이 이와 유사하다 할 수 있겠다.

다시 말해, 참을 수 있을만한 불편함으로 얻을 수 있는 새로운 경험의 폭을 우리는 옥상에서 발견할 수 있게 된 것이다. 국립현대미술관 과천의 이번 프로젝트에서 우리는 완벽한 건축 공간을 기대하는 것이 아니라, '옥상'에서만 경험할 수 있는 특정한 상황을 예측하고, 이를 자연스럽게 방문자들에게 투사하며(projecting) 제공하는(providing) 데서 이 프로젝트의 의미를 찾아야 한다고 본다. 다만 일반 건축물의 옥상 활용안과 그 중요성과 무게감이 다른 이유는, 미술관의 기존 건물이 가진 의미와 역사성, 그리고 완결성의 맥락이 다른 어떤 건축물보다 중요하기 때문이다.

분명 과거부터 그 자리에 있었으나 사람들의 인식에는 존재하지 않았던 옥상 공간을 방문자들의 인식에 새롭게 심어 넣음으로써, 관람이라는 여정의 마지막에 꼭 가봐야 하는 장소로 전환해야 하는 이 숙제는 결코 쉽지 않다. 요즘 표현으로 인생 샷 한두 개는 건질 수 있는 다양성이 존재해야 하며, 정교하지만 이해하기 쉬운 스토리와 장소성도 부여돼야 한다. 단지 아름다운 주변 풍광이 존재한다는 것만으로 새로운 집객의 효과를 기대하기란 쉽지 않다. 머물 수 있는 장치적 속성도, 경관을 새롭게 해석하며 느낄 수 있는 작업으로서의 새로움도 분명 존재해야 한다. 또한 무엇보다 그 자체가 기존 건물과의 대비 또는 동화를 통하여 또 하나의 새로운

풍경이 되어야 한다. 이러한 맥락에서 당선작 이정훈 건축가의 〈시간의 정원〉은 국립현대미술관 과천관 옥상의 장소성을 가장 적극적이며 새롭게 해석한 것으로 인정되었다.

당선작 〈시간의 정원〉과 최종 후보군 제안작의 의의

이번 프로젝트 당선작은 이정훈(조호건축)의 〈시간의 정원〉이다. 〈시간의 정원〉이라는 제목이 말하듯이, 이 작업은 시간의 흐름에 따라 회화적으로 변화하는 그림자의 밀도를 옥상에서 펼쳐지는 경관의 다양함으로 해석한다. 세밀하게 뻗어나가는 철제 루버 부재들 또한 새로운 경관의 레이어로 활용한다. 주변 풍경은 관람자의 동선에 따라서 구조물들 간의 시각적 중첩으로 인해 사라지기도 하고 부분적으로 나타나기도 하는 변화의 시퀀스를 만들어낼 수 있다. 또한 어느 지점에 이르러서는 부재들의 간섭이 전혀 없이 주변 풍경을 그대로 끌어들이기도 한다. 결국 관찰자의 움직임과 위치가 풍경의 차이를 연속으로 생산하며 고정된 구조물에서 키네틱한 시각 경험을 만들어낸다는 점이 놀랍고 또한 역설적이기까지 하다.

중정에 자리 잡은 기존 정원도 이 새로운 구조물이 만든 그림자에 통합되어 입체적으로 해석된다는 점이 이 작업의 또 다른 매력이다. 대낮 옥상에 드리워진 그림자로 형성되는 그늘은 옥상의 공허함을 상쇄함과 동시에 관람자들에게 휴식의 공간을 제공한다. 이 점에서 옥상에 그림자를 시시각각으로 공급해 준다는 것은 루프톱에서 가장 중요한 휴게 공간 기능이라고 볼 수 있다. 해가 진 후 세밀한 구조체들과 조명의 관계가 만들어내는 아름다운 경관도 새로운 기대감을 주기에 충분하였으며, 예산을 절감하는 건축가의 치밀한 공정과 제작에 관련한 놀랄만한 코디네이션 능력 또한 상당한 신뢰감을 주었다. 전체적으로 합리적 구조미와 경제성 그리고 기존 문맥과의 놀랍도록 정교한 조율은 이 작업이 당선작으로 선정되는 데 전혀 부족함이 없었다고 본다.

당선작이 보여준 프로젝트 해석의 완성도와 훌륭함은 물론이고, 비록 선정되진 않았지만 중요한 지점을 나름대로 해석하여 치밀함과 집중력을 가지고 전개해 나간 다른 작업들의 훌륭함도 언급하지 않을 수 없다. 개개의 작품 설명을 듣는 동안 깊은 공감을 느꼈으며, 참가자들의 참신하며 다양한 논조는 필자에게 많은 영감을 주기에 충분했다.

당선작 외에 프로젝트 제안작은 김이홍(김이홍 아키텍츠)의 〈정형의 변형〉, 박수정, 심희준(건축공방)의 〈과천오름〉, 박희찬(스튜디오 히치)의 〈돌의 부활〉, 이석우(SWNA)의 〈생각의 대기〉이다.

김이홍(김이홍 아키텍츠)의 〈정형의 변형〉은 국립현대미술관 과천이 옛날부터 가지고 있었던 숨겨진 이야기를 마치 고고학적 고증을 하듯 발굴해 나가는 개념적 접근이 무척이나 매력적인 프로젝트이다. 기존 건물의 서사를 먼저 풀어내며 새로운 구조물을 시작하는 인트로의 강렬함은 아직도 기억에 남는다. 미술관 경험을 로툰다의 램프에서 끌어올려 실내에서 실외로 확장하는 세련된 연출은 기하학적으로나 동선의 연속성 관점에서도 무척 설득력 있는 제안이다.

박수정, 심희준(건축공방)의 〈과천오름〉은 방문자들의 행위를 다양하게 예측하여 그에 맞는 여러 가지 장치적 속성을 단순한 구조물의 미세한 단면 변화 안에서 제안하였다는 점이 인상적이었다. 평상과 같은 낮은 위치에서 서서히 올라가는 단계, 그리고 전망의 포인트에 이르기까지 앉고, 오르고, 서서 바라보는 방문자의 능동적 개입으로 풍광을 다양하게 경험할 수 있는 장치는 현실적이며 합리적이다. 유니크한 블루 색상을 구조체에 제안함으로써 맑은 하늘과 블랜딩하려는 의지도 시적이며 흥미로웠다.

박희찬(스튜디오 히치)의 〈돌의 부활〉은 다른 안들과 비교하여 최소한의 건축적 개입으로 새로운 장소성을 만들려고 한 작업으로, 이 프로젝트를 바라보는 시선의 차별화로는 가장 신선하다고 느낀 프로젝트이다. 돌 이야기로 시작되는 프로젝트 서사는 무척 지적이며 감동적이기까지 하다. 현재 옥상 바닥에 깔려있는 돌을 공장으로 가지고 가서 21세기 방식대로 재탄생시켜 원래 자리로 되돌려 놓는다는 의미 전달이 강렬했으며, 작은 디테일에 스토리를 실어 나르는 역량과 기획의 힘도 아름다웠다.

이석우(SWNA)의 〈생각의 대기〉는 유일하게 국립현대미술관 과천과의 물리적 또는 역사적 맥락의 연장을 이야기하지 않는다. 그러나 이 새로운 시선은 충분히 환영받을 만큼의 타당함과 자유로움으로 표현되며 매력적인 작업으로 귀결된다. 관람자 여정의 마지막 단계에서 영감의 장소로서 루프톱의 역할은 자연을 보여주는 또 다른 전시관으로 치환될 수 있다는 가능성을 설득력 있게 이야기한다. 넓게 열린 하늘과 구름을 색다른 방식으로 옥상정원에 끌고 들어오고자 다양한 방향으로 꽃봉오리같이 설치되는 스테인리스 미러 패널 오브제가 무척 서정적인 제안이다.

에필로그

이번 국립현대미술관 과천 옥상정원 재생 프로젝트는 규모는 작지만 의미에 있어서 결코 작지 않은 어려운 과제이다. 일단 건축물 자체가 건축가 김태수의 가장 중요한 작업의 하나로서, '기존의 건축적 의미를 유지한 상태에서 새로운 부가적 행위를 기존과 조율할 수 있는' 방법을 찾는 것은, 단언컨대, 참가자에게 많은 고심의 시간을 요구했을 것이다. 기존의 건축적 맥락을 심도 있게 작업의 출발점으로 삼은 제안부터 관람자의 행동 패턴이나 새로운 경험에 더 많은 비중을 둔 안까지, 다양한 스펙트럼의 존재는 이 공모전의 의의가 무엇인지를 생각하게 해준다.

앞서 이야기한 해방촌 루프톱처럼 상업적 논리에서 출발한 프로젝트는 아니지만, 그럼에도 불구하고 이 프로젝트 또한 사용 빈도가 낮은 도시 내 장소를 발견하고, 새로운 기능과 의미를 부여해 집객의 효과를 극대화한다는 점에서 유사한 맥락을 공유한다. 여기서 우리가 중요하게 보아야 하는 관점은, 기존 건축과의 관계성도 물론 고려해야 하지만, 왜 사람들이 굳이 더 많은 힘을 들여서 옥상까지 가야만 하는지에 대한 당위성을 만들어주어야 한다는 것이다. 그러한 측면에서 옥상은 어찌 보면 '새로운 기대의 공간'이 되어야 할 필요가 있다. 일종의 엑스트라 콘텍스트(extra context)로서, 기존 건물 내부에서의 경험 및 감성과는 다른 체계가 주변 환경과 어떻게 반응하여 새로운 스토리와 경험을 만들어 사용자들에게 제공하는지가 관건이라고 할 수 있겠다.

여기서 중요한 부분은 크리에이터의 '관점의 전환'이다. 즉 공간의 완결성이나 구축 논리에 대한 비중이 너무 큰 나머지 관람 또는 사용자의 관점이나 행동 방식이 상대적으로 가볍게 여겨지는 경우를 종종 본다. 학교 교육부터 시작해서, 지속적으로 자신의 개념을 지키고자 논리와 경험적 힘으로 무장해 왔던 숙련된 크리에이터의 경우 더욱 그러한 실수에 빠지기 쉽다. 작업의 완결성도 무척 중요하나 그보다 더욱 중요한 것은 사람들이 오게끔 만드는 것이고, 이를 위해 우리는 사소한 것부터 차근차근 챙겨야 한다. 어린 자녀들과 함께 온 부모님이 머무를만한 위치가 어디쯤 될 것인지, 연로자가 잠시 햇살을 피할만한 그늘이 존재하는지, 젊은 연인이나 친구들이 어떤 구도에서 사진을 찍게 될 것인지 등을 고민하는, 사용자 중심으로의 관점 전환이 이러한 옥상 개선 프로젝트에서는 더욱 면밀하게 검토되고 실행되어야 한다. 옥상은 여전히 별도의 노력을 더 들여야만 갈 수 있는 중심 외 공간이기에 더욱 그러하다.

다행스럽게도 이번 공모전은 모든 작업이 나름의 해석으로 사용자 관점을 적극 고려했다. 몇 년 전과는 확연히 다르게 크리에이터들이 사용자 중심 사고로 전환했음을 발견할 수 있었다는 점에서도 앞으로의 공간 재생 사업이 가져올 실질적 변화에 대한 큰 기대를 감출 수 없다.

김찬중

고려대학교 건축공학과를 졸업하고 스위스 연방공과대학교에서 수학하였으며 미국
하버드대학교에서 건축학 석사 학위를 취득하였다. 국내외에서 실무를 쌓은 후
귀국하여 현재까지 경희대학교 대학원 건축학과 설계전공 초빙교수로 재직하면서
더_시스템랩의 대표로 활동하고 있다. 2006년 제10회 베니스비엔날레에 참여, 같은 해
베이징국제건축비엔날레에서는 '주목받는 아시아 젊은 건축가 6인'에 선정되기도 했으며,
2016년에는 영국 『월페이퍼』지가 선정한 '세계의 떠오르는 건축가 20인'에도 선정되었다.
대표작으로는 한남동 오피스, 하나은행 삼성동 PLACE 1, 울릉도 KOSMOS 리조트,
우란문화재단, 마곡 서울식물원 온실, JTBC 신사옥 등이 있다.

The Significance of Museum Rooftop Space Regeneration

Kim Chanjoong
(Principal architect, THE_SYSTEM LAB; visiting professor, Department of Architecture, Graudate School of Kyung Hee University)

As the architects of neighborhood living facilities did not take into account heating, cooling, ventilation, communications, and other diverse systems in the early stages of designing the buildings, the rooftops of such facilities have long been somewhat awkwardly utilized as the only remaining space to install such additional systems. As a result, rooftops, often stacked with mechanical equipment, have been separated from our lives and regarded as disarranged spaces with unknown dangers.

The concept of the rooftops in the West actually used to be an unfamiliar object of admiration to us. But this perception has been changed in a way thanks to the urban situation of Haebangchon, which was regarded as one of the most backward parts of Seoul in the past. In recent years, its rooftops have been commercially transformed into cafés and restaurants, taking advantage of the visual openness of the nearby Namsan Mountain. Now, as the rooftops in Haebangchon have become hot spots, it is no longer unusual for people to wait in line and climb up narrow, uncomfortable stairs to enjoy a cup of tea and take lots of photographs at rooftop cafés or restaurants.

The potential of rooftops to become these sorts of spaces brought them back into the spotlight, and the rediscovery of this neglected space led to the "discovery of a new landscape." People realized that the best way to experience nature in an urban space is not that of simply looking at it through a large window, but the multi-sensory experience of feeling the wind on one's skin, listening to the sounds, and smelling the air. This experience might be similar to how we experience the landscape with our whole body when riding a bike, not taking a car.

In other words, now we can discover a new range of experiences on rooftops that can be gained from bearable discomfort. In the National Museum of Modern and Contemporary Art, Gwacheon (MMCA Gwacheon) Project, I think that we should not expect a perfect architectural space, but find meaning in predicting specific situations that can be experienced on the "rooftop," then naturally project and provide these to viewers. The project is different from other plans for rooftops of general-purpose buildings in terms of importance and weight, since the meaning, history, and completeness of the MMCA Gwacheon building are much more significant than that of most other buildings.

It is not easy to give visitors a new impression of the Rooftop, which has always been up there but never been noticed, so that the space

can be perceived as a must-visit destination at the end of one's journey around the museum. To this end, the Rooftop must have not only photo spots where visitors can take some excellent pictures, but also a sense of place and an elaborate but easy-to-understand story. It is difficult to expect the beautiful surrounding scenery alone to attract new visitors. The Rooftop must have devices to keep visitors around as well as a fresh, new interpretation of the scenery. And above all, the space needs to become a new landscape by contrasting or harmonizing with the existing building. In this context, the winning project *Garden in Time* by architect Lee Jeonghoon was recognized as the most bold and fresh interpretation of the palceness of the Rooftop at MMCA Gwacheon.

The Significance of the Winning Work *Garden in Time* and Other Projects on the Shortlist

The winner of this project is *Garden in Time* by Lee Jeonghoon (JOHO Architecture). Reflecting its title, the project interprets the density of shadows, which picturesquely change with the passage of time, as a variety of landscapes unfolding on the Rooftop. The elaborately stretched metal louvers also serve as a layer of a new landscape. The surrounding landscapes can appear and disappear in changing sequences according to visitors' lines of movement or the visual overlapping of structures. And at certain points, visitors can enjoy the surrounding landscape without the interruption of structural objects. In brief, it is amazing and paradoxical at the same time that kinetic visual experiences can occur within a fixed structure as the movement and changing location of an observer create a sequence of shifting landscapes.

Another factor that makes this work compelling is that the relationship between the Rooftop and the existing second-floor garden visible from its central courtyard is interpreted in a three-dimensional manner as the shadows of the new structure connect the garden to the Rooftop. The shadows cast on the Rooftop during the day not only offset the emptiness of the space but also provide a shady place for visitors to rest. In this regard, the continual provision of shadows and shade might be the most important role of the rooftop as a relaxing space. The beautiful scenery created by the relationship between the exquisite structures and lighting after sunset arouses new expectations, and the architect deserves credit for his remarkable coordination of the meticulous process and production that could reduce the budget. Given the overall beauty of the reasonable structure, its remarkably elaborate harmony with the existing context, and the proposal's economic feasibility, this work is fully deserving of its selection as a winner.

Although *Garden in Time* is an excellent and perfect interpretation of the project, I must mention the brilliance of the other proposals as well, which were elaborate and focused in their own interpretations of some important points. I deeply empathized with each participant while listening to the description of their proposals, and their fresh and diverse arguments truly inspired me.

The other proposals included *Tweaking Symmetry* by Kim Leehong (Leehong Kim Architects), *Gwacheon OREUM* by Park Su-Jeong and Sim Hee-Jun (ArchiWorkshop), *Stone Resurrection* by Park Heechan (Studio Heech), and *Atmosphere in Thought* by Lee Sukwoo (SWNA).

Tweaking Symmetry by Kim Leehong (Leehong Kim Architects) presents quite an attractive conceptual approach, aiming to discover a hidden story of MMCA Gwacheon based on a kind of "archeological research." I still remember this proposal's powerful intro, which began with the narrative of the existing building. The sophisticated goal of extending the experience of the museum from the interior to the exterior through the ramp of the rotunda was convincing in its use of both geometry and continuous moving lines.

Gwacheon OREUM by Park Su-Jeong and Sim Hee-Jun (ArchiWorkshop) was impressive in that it proposed various technical modes to accommodate the spectrum of visitors' unpredictable behaviors within a simple structure that would inflict minimal and superficial change to the building. The device would allow visitors to experience the scenery in various ways through active engagement, such as sitting, ascending, and standing at the device from positions as low as a wooden bench or as high as a viewing point. These uses seemed practical and reasonable, and the intent to blend the structure with the clear sky through the application of a unique blue color was poetic and interesting as well.

Stone Resurrection by Park Heechan (Studio Heech) aimed to create a new sense of place with minimal architectural intervention compared to other proposals, making it the freshest in terms of its differentiated perspective on the project. The narrative of MMCA Gwacheon Project, which begins with a story of stone, is extremely intellectual and even touching as well. The proposal conveyed a powerful message of taking the stone on the Rooftop floor to a factory, renewing it in a 21st-century way, and bringing it back to the museum. Park displayed a beautiful ability to deliver a story in detail as well as the power of design.

Atmosphere in Thought by Lee Sukwoo (SWNA) is the only proposal that did not discuss the extension of the physical or historical context of the MMCA Gwacheon. Despite that, it expressed a new

perspective in acceptably reasonable and free ways, producing a compelling work. It delivered a convincing argument that the Rooftop, as an inspirational place at the end of a visitor's journey through the museum, can serve as an additional exhibition space where nature is on display. It is quite lyrical to propose the installation of an object with stainless mirror panels, which would spread out in various directions like a budding flower to draw the broad sky and clouds to the Rooftop.

Epilogue

MMCA Gwacheon Project 2022: Rooftop may be a small project in terms of its scale, but it is a rather difficult task, and its significance is far from small. Since the MMCA Gwacheon building is one of architect Kim Tai Soo's most important works, participants in the project must have spent a long time finding ways to enable "a new, additional structure to harmonize with the existing building, maintaining the original architectural meaning." The broad spectrum of proposals, from one that began with the existing architectural context to another that focused more on visitors' behavioral patterns and new experiences, allows us to reflect on the significance of this contest.

Unlike the development of rooftops in Haebangchon, this project is not based on commercial logic, but both cases share a similar context in that they have discovered an underused urban space and now provide new functions and meanings to maximize the effect of attracting visitors. To this end, although there is a relationship between the rooftop and the existing building, it is important to provide appropriate reasons as to why people would take the extra effort to go to the rooftop. In this regard, rooftops need to be a "place for new expectations." This is a kind of an extra context that stems from how a new system that is different from what visitors feel and experience inside an existing building can create and provide a new story and experience in response to the surrounding environment.

What is important here is a "shift in the creator's viewpoint." The viewpoints or behavior patterns of users are often regarded as relatively less important than the completeness of a space or its constructional logic. Particularly skilled creators, who have defended their concepts with the power of logic and experience since they were students, are more prone to such errors. Although the completeness of a work is important, what is more important is to make more people enter it, which requires us to care about the little things first. Therefore, in such rooftop regeneration project, it is crucial to scrutinize user-centered viewpoints-such as where parents

with young children can stay, whether there will be enough shade to allow older people to stay out of the sunlight, and from which angles young lovers or friends will take photographs-to find solutions. It is especially so because the rooftop is a non-central space that can only be entered through extra effort.

Fortunately, all proposals submitted to this contest adopted such user-centered viewpoints through their various interpretations. The shift towards creators' user-centered viewpoints which is a big change compared to past architectural proposals, raises expectations about the practical changes that space renewal projects will bring in the future.

Kim Chanjoong
Upon graduating from Korea University with a bachelor's degree in Architectural Engineering, Kim Chanjoong studied at the Swiss Federal Institute of Technology Zurich (ETH) and earned his master's degree in architecture from Harvard University. After acquiring experience from Korea and abroad, he returned to Korea and is currently serving as both a visiting professor at the Department of Architecture, Graduate School of Kyung Hee University and the principal architect in charge of THE_SYSTEM LAB. In 2006, Kim's work was showcased at the 10th Venice Biennale, and the same year, he was nominated as one of six emerging young Asian architects by the Beijing International Architecture Biennale. Kim was also selected as one of 20 emerging global architects by *Wallpaper*, a British architecture magazine. His major works include the Hannam-dong HANDS Corporation Office; Hana Bank Place 1, Seoul; the Kosmos Resort, Ulleungdo Island; the Wooran Foundation; Seoul Botanic Park; JTBC.

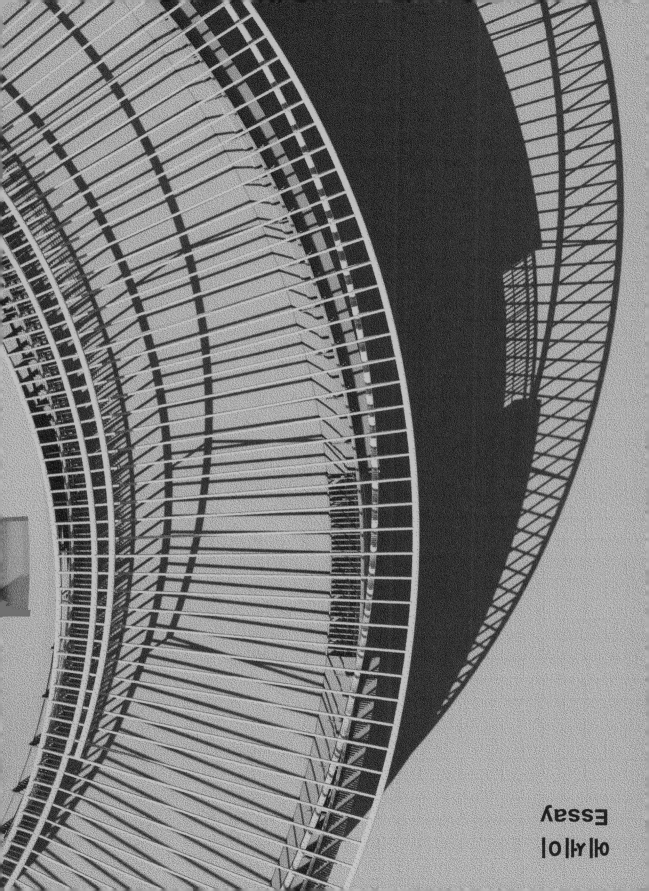

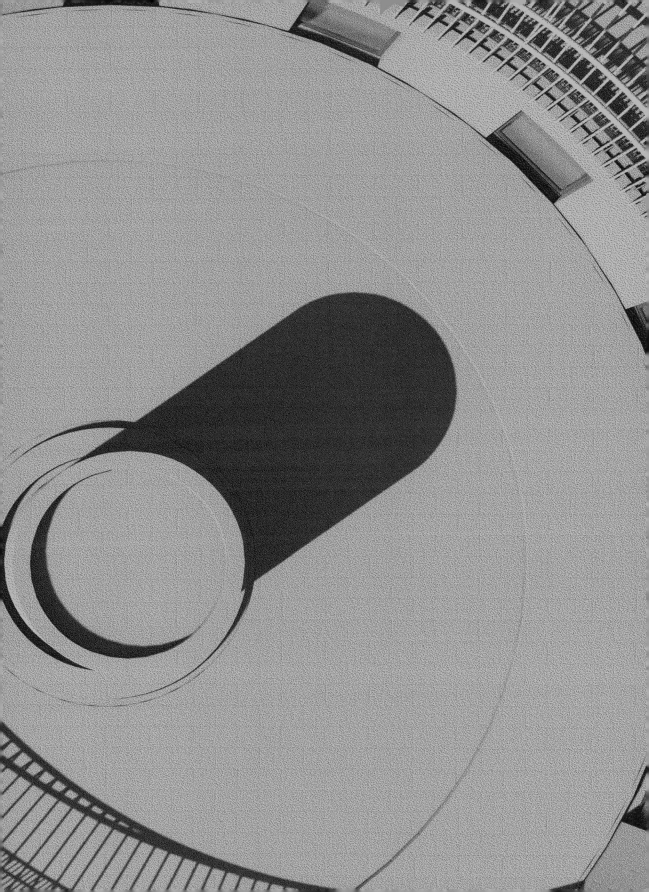

시간의 동화

편집진
(아트앤페이지 대표, 전 『동기』 편집장)

1 건축의 기본 골격을 벽으로부터 독립된 최소한의 기둥과 바닥으로 정의한 르코르뷔지에의 이론으로, 근대건축의 산업화와 확산에 결정적으로 기여했다.

2 콘크리트를 부어서 한 장의 판처럼 만든 평평한 바닥 구조물로, 보통 층 사이를 구분해 준다.

잃은 것과 얻은 것

20세기를 전후해 태동한 근대건축으로 이 세계는 잃은 것과 얻은 것이 있다. 전통과의 단절을 선언한 모더니즘은 지역성을 탈색하고, 건축의 오랜 조형과 의장 그리고 낭만과 표현을 상실했다. 그럼 반대로 얻은 것은 무엇이었나. 산업으로서의 건축, 더 크고 높은 건축, 그리고 세부로는 고루한 박공지붕을 대신하는 옥상이었다. 이 옥상은 르코르뷔지에의 근대건축 5원칙에 직접 등장하거니와 다른 원칙의 현현에도 기여했다. 르코르뷔지에는 필로티로 대지를 건물에서 해방하고, 동시에 공중에 떠 있는 인공의 대지로서 옥상정원을 제시한 바 있다. 그가 주창한 돔이노 시스템(Dom-Inno System)[1]은 한편으로 이런 이상적인 대지와 옥상을 잇는 가장 합리적이고 빠른 중간 체계였을 것이다.

《MMCA 과천프로젝트 2022: 옥상정원》은 근대 옥상정원과 기표를 같이하지만, 이념과 기의의 차이를 전제로 출발한다. 근대 이상주의자의 이론이 산업과 생산이라는 측면을 넘어 인간 정서와 삶과 마주하면서 얼마나 큰 갈등과 문제를 불러왔는지 우리는 이미 경험했다. 평슬라브[2]를 쌓아 올리며 얻은 마지막 순간의 옥상이 근현대 도시적 삶에선 어떤 공간이었을까? 현대건축의 복잡한 기계 설비와 소음에 점령당한 채, 대부분 산책과 여유와는 거리가 먼 하부 공간으로 작동해 왔다. 근대의 이상에 천착하는 건축가들은 아직도 자신의 순수한 공간적 사고를 옥상에 대입하고, 커튼 월로 외기 접촉이 원천적으로 차단된 건물 속에서 이용자들이 머리 꼭대기의 옥상을 선택해 줄 것이라는 기대 속에 작업을 한다. 주변의 경관과 전망, 기계 설비의 상황, 수월한 접근성과 조경 등이 보장되지 않는다면 건축가의 이 같은 의도는 담배꽁초 즐비한 흡연 공간으로 초라하게 쪼그라드는 것을 무수하게 지켜보았다.

국립현대미술관 과천관 설계자인 건축가 김태수 또한 이런 근대적 사고로 3층 옥상정원을 설계하지 않았을까. 지금까지 수십 번 과천관을 방문했던 나조차도 옥상정원의 존재를 이번에야 알았다. 이곳은 숨겨진 비밀 정원이었을까, 아니면 안전과 통제라는 이유 아래 방치된 공백이었을까. 이번 옥상정원 프로젝트는 이렇듯 근대건축이 말하는 옥상정원에 대한 반성적 성찰이자 장소의 회복이고, 미술관 내 유휴 공간을 무대화한 새로운 접근이다. 당선작으로 선정된 건축가 이정훈의 〈시간의 정원〉 또한 근대와 동시대 옥상정원이 갖는 기의의 차이 속에서 창발적으로 새로 피어난 장소인 것이다. 작가는 근대건축이 구축한 이성과 순수 기하학의 영토에서 동시대에 걸맞은 다원화된 문화적 경관을 창출해야 했다.

그래서 올해 과천프로젝트에서 가장 눈에 띄는 것은 주어진 사이트다. 1회 프로젝트 대상지였던 과천관 야외조각공원은 다양한 건축 알레고리와 표현이 가능한 탈문맥 상황이었고, 2회 때의 예술버스쉼터 또한 쉘터(shelter)라는 최소한의 기능이 개입되었을 뿐 입체 조형에 더 가까웠다. 그에 반해 올해 프로젝트는 옥상이라는 인공 대지가 주어졌고, 하나로 응집할 수 없는 선형 경계 위에서 김태수라는 원로

건축가의 생각 속을 헤집고 다녀야 하는 난제에서 출발했다.

시간의 형체 없음을 지각하는 방법

그렇다고 〈시간의 정원〉이 근대의 거대 담론에 맞선 안티테제로 출발한 것은 아니다. 오히려 이정훈은 아주 작은 현상과 순간의 경험에서 작품을 구상하기 시작했다. 프로젝트 공모 단계에서 이뤄진 현장 답사에서 작가는 3층 옥상정원 주변에 설치된 스테인리스 난간에서 영감을 얻었다고 한다. 어떤 공예적 요소나 개체성 없이 오로지 안전을 위해 덧붙여진 1.2미터의 난간에서 하늘과 맞닿은 이 순수한 장소의 가능성을 읽은 것이다. 10센티미터 간격으로 늘어선 난간 살들이 안전 구조물이라는 본연의 태생을 잠시 잊고 그곳의 빛과 어우러졌을 때 이정훈도 그 풍경의 순간 속에 있었다. 사실 이런 식의 난간은 건축의 완성도에 도움이 되지 않는다. 그래서 오늘날 건축에서 난간은 공예성을 잃고 구조와 형태가 최소화되면서, 물성조차 점점 사라지고 있는 추세이다. 〈시간의 정원〉은 이런 건축의 미시 풍경을 정서적으로 증폭해 만든 작품이다. 난간 풍경에서 영감을 얻어 시작되었지만, 이 작품은 어느 지점에서 난간이 아닌 다른 공간과 구조물의 차원으로 진입한다. 우리는 이 속에서 시간을 어떻게 의식하고, 느낄 수 있을까?

그리스 신화에서도 시간의 신인 크로노스만큼은 본래 형체가 없었다. 이렇게 형상과 질료 이전에 존재하는 시간이라는 개념과 추상을 건축은 어떻게 담을 수 있을까? 이럴 때 건축가가 빛과 그림자를 떠올리는 것은 그다지 어렵지 않고, 또 창의적인 발상도 아니다. 공간을 다루는 건축가에게 시간은 빛의 떠오름과 머무름, 그리고 이동과 사라짐으로 늘 의식하고 확인해야 하는 대상이기 때문이다. 작품 제안서에 실린 짧은 문장 속에서 작가가 갖고 있는 시간과 공간에 관한 관념을 엿볼 수 있다.

시간에 정원이 있다면 그것은 어떠한 형체일까? 기하학적 공간 속 시간이란 자신을 무한히 소거함으로써만 존재할 수 있다. 그것은 절대 공간이 지닌 엄숙함 속에 자신을 무한히 숨겨야만 자신이 존재할 수 있기 때문일 것이다. (...) 만약 시간에 물성이 있다면 그것은 어떤 형태로 드러날 것인가? 이곳에서 시간은 공간을 가로지르며 새로운 형체로 자신을 드러낸다. 시간은 빛에 의한 그림자로, 그것들 총합의 입체로 자신을 증명해 낸다.

보이지 않는 시간을 보이도록 하는 일, 이는 건축가에게 결국 형상의 문제로 다시 귀착될 수밖에 없다. 〈시간의 정원〉을 구축하기 위해 동원한 빛과 그림자가 일반해라면, 작가의 특수해는 옥상정원 전체를 지배하는 구조물이다. 난간 살이라는 수직 부재와 핸드레일이라는 수평 부재의 기하학적 만남이 결국 이곳에서 보이지 않던 시간을 펼쳐 보여준다. 언뜻 난간에서 이어지는 수직 부재와 살들이 그림자 출현에 더 크게 기여할 것 같지만 실제로 옥상정원 외경과 내경에 맞춰 함께

떠있는 4개의 원형 링이 이들을 받아주고, 또 이 링들이 서로 다른 각도로 기울어져 교차하고 중첩되면서 다양한 시간의 풍경을 이뤄낸다. 원형 링 기울기에 따라 난간 살 높이가 달라지고, 이로 인해 들떠있고 잠겨있는 빛의 정원을 거닐 수 있게 된다. 자신을 소거해야 했던 엄숙한 기하학의 공간은 이제 빛과 그림자의 드라마 가운데 해체되고, 다시 '나'와 지금의 '시간'을 중심으로 재구축된다. 원형의 균질함에 마침내 균열과 차이가 생긴다. 그리고 적극적으로 다뤄지진 않았지만 3층 옥상정원 안쪽으로 위치한 2층 원형정원은 정원의 시간에 공간적 깊이를 더해준다. 2층 원형정원은 시간의 존재와 흐름이 아닌 시간의 두께와 깊이를 말없이 느끼게 한다.

작가는 이곳에서 질서를 만들고 변주해 가면서 방문자들의 경험 시퀀스를 새롭게 구성하였다. 문을 열고 밖으로 나와 옥상정원에 진입한 이후 주변 풍광은 움직임에 맞춰 가려지고 열리며, 쪼여지고 넓혀지며 조율된다. 시선은 안을 향하다 밖으로 탈주하고, 기하학을 응시하다 자연으로 돌아선다. 안으로는 옥상정원과 구조물이 갖는 순수 기하학의 세계가 존재하고, 밖으로는 주변 산세와 자연의 세계가 존재하는데, 안과 밖, 기하학과 자연이라는 서로 다른 이 두 세계의 다이얼을 돌려 맞춰가며 방문자의 감각적 경험을 이끌어가는 것이다.

난간 그림자가 길게 늘어진 어느 겨울 아침, 아무도 걷지 않은 옥상정원을 돌며 눈 덮인 주변 산세 속에 잠시 자신을 밀어 넣고 있을 내 모습이 불현듯 그리워진다. 그 순간만큼은 다가올 시간도, 지나갈 시간도 잠시 멈추어 기다려주지 않을까. 나는 차가운 바람을 맞으며 바닥에 새겨진 이 시간의 음화를 바라볼 것이다. 그리고 다시 비워진 이곳엔 다른 시간의 풍경이 들어와 나의 빈자리를 채울 것이다.

기술로 감각하는 추상

〈시간의 정원〉은 관념적 사유에서 출발했지만, 이를 구체화하는 단계에서는 철저하게 기술 기반의 건축 생산 방식이 적용되었다. 하나의 오브제처럼 특정 지점에 설치하는 것도 아니고, 부분의 합이 바로 전체를 이루는 단조로운 구성이 아니기 때문에 제작에서 부분과 전체를 긴밀하게 연결할 기술이 필요했다. 여기서 건축가 이정훈이 가진 기술 지향적 태도와 수학적 사고가 없었다면 이런 설계는 물론이고, 현실의 문제 해결도 어려웠을 것이다.

이번 작품은 부분의 논리가 매개 변수로 전체를 이뤄나간다. 가상 세계에서 수학적 사고로 구축된 이상적 모델링, 그리고 1980년대, 계측과 숫자보다는 장인들의 감에 의해 만들어졌을 불완전한 옥상정원의 현 상태. 이 두 세계 사이의 오차와 간극을 메워간 것은 3D 스캔을 통한 현실 계측과 BIM(Building information modeling)을 활용한 설계 방법론이었다. 이렇게 정밀하게 계산되어 설계된 텐션 구조가 아니었다면 옥상정원에 가볍게 올려진 직경 39미터의 이 하얀 날갯짓을 보지 못했을 것이다.

BIM을 사용해 설계된 모든 부재는 공장에서 사전 제작되고, 현장에서 빠르게 조립 설치된다. 이정훈은 이 같은 건축 생산 방식을 앞서 클럽나인브릿지 파고라에서 실험한 바 있다. 철골과 유리로 지금보다 훨씬 난이도 높은 비정형 건축을 BIM과 공장 제작으로 만들면서 자신의 방법론에 확신을 가졌을 것이다. 이번 작품이 영구 설치가 아니므로 차후 있을 해체 작업을 생각한다면, 이 같은 생산 방식이 더 적합할 수 있다. 빠르게 제작하고, 가볍게 설치하고, 손쉽게 해체할 수 있는 구조. 이번 프로젝트는 결국 오브제 차원을 넘어서 옥상이라는 장소 전체를 다루면서, 제작과 설치 그리고 해체 등 작품의 존재론적 시간성까지 기술적으로 다루어야 했다.

회복하는 공간의 두께

서두에 근대건축이 옥상을 얻었다고 말했지만, 반대로 이 때문에 우리는 지붕을 희생했다. 아니 정확히 말해 지붕의 두께를 내주었다. 근대건축은 지붕을 얇은 평슬라브 한 장으로 대체하면서 그 공간의 두께와 조형, 물성을 지워버렸다. 그리스 시대 건축은 기둥 위로 지붕을 세우기까지 엔타블러처(entablature)[3]와 페디먼트(pediment)[4]를 두었는데, 그 공간의 두께 속에서 건축은 얼마나 풍요로운 예술적 요소와 장식을 누렸던가. 이 두께야말로 예술로서 건축의 지위를 있게 한 가장 중요한 부분이기도 했다. 그것은 지역 문화와 기후에 따라 성격을 달리하며 공간의 풍요를 만들어준 숨은 공신이었다. 한국 전통건축에서 지붕에 속한 공포의 의장과 처마 공간의 두께를 생각하면 알 수 있다.

건축가 이정훈의 다른 작업에서도 현대건축에서 퇴화한 지붕 하부 공간의 두께를 회복하려는 기술적, 개념적 노력을 엿볼 수 있다. 물론 그가 고전건축처럼 그것의 의장적, 예술적 개별성과 표현에 몰입하는 것은 절대 아니다. 오히려 그는 그 사이에서 동시대건축이 간과하는 자연과 내부의 연결에 집중한다. 이번 〈시간의 정원〉에서 빛을 다루려는 시도처럼 그는 다른 건축작업에서도 통상적인 입면 창이 아니라 지붕과 그 하부 공간을 이용해 빛과 자연을 다루려고 노력한다. 최근작인 양양의 설해원 클럽하우스 증개축에서도 매스마다 다양한 지붕 기울기와 두께를 만들어가면서 빛과 풍광을 유입시키고, 내부 공간의 새로운 연출을 시도하였다. 안에서 지붕 위로 창을 올려다보았을 때 하늘과 나 사이에 제3의 감각층이 존재하는 모습이다. 과천의 선유재에서는 의식적으로 한국 전통건축 지붕과 처마를 현대적으로 해석해 표현했는데, 〈시간의 정원〉과 유사한 스테인리스 파이프를 사용해 처마 하부 표면을 현대적으로 만들었다. 그리고 그 두께 안쪽에서는 패시브 하우스(passive house)[5] 기능을 만족시키고자 대기 순환과 빛 유입을 적극적으로 시도했다. 그의 건축에 등장하는 입면 기하학과 패턴은 종종 이렇게 만들어진 지붕 하부 공간을 어떻게 몸체와 통합할 것인지, 아니면 분리해 개체화할 것인지를 고민한 결과이기도 하다. 경기도 위례에 위치한 어시메트릭 하우스는 이렇게 형성된 지붕 하부 공간이 움푹 파인 독자적 볼륨과 형태로 강조된 사례이기도 하다. 〈시간의 정원〉 또한 이런 관점에서 기울기가 다른 4개 링이 만들어낸 지붕 구조로서,

3 기둥 윗부분에 수평으로 연결돼 지붕을 덮는 장식 부분의 총칭.

4 고대 그리스 로마 시대 건축물의 박공으로, 엔타블러처 윗부분에 연결된 삼각형의 장식 부분.

5 첨단 단열 공법을 이용하여 집 밖으로 열이 새 나가지 않도록 최대한 차단함으로써 에너지 낭비를 최소화한 건축물.

모든 공간이 다른 두께 값을 갖는다. 지붕 구조의 두께와 높이 변화로 빛과 그림자의 차이가 생성된다. 다만 다른 점이 있다면, 앞선 건축작업들이 포지티브 관점에서 어떻게 빛을 내부로 받아들여 공간을 채울지 고민한 것이라면, 〈시간의 정원〉은 그 두께를 비물질화하고, 마치 네거티브 음화처럼 그림자를 공간에 아로새긴 것이다.

박성진
사이트앤페이지의 대표로, 건축과 공간을 기획하고, 이를 주제로 콘텐츠를 만든다. 한국예술종합학교와 스페인 마드리드공과대학교에서 건축이론역사를 공부했으며, 이를 밑천 삼아 공간 기획, 디자인 컨설팅, 출판, 전시, 연구 조사, 교육 등의 활동을 전방위로 이어가고 있다. 앞서 월간 『SPACE(공간)』 편집장을 역임하면서 오늘날 건축에 대한 총체적 시각과 경험, 네트워크를 다졌다. 현재 유한책임회사 초현실부동산 대표를 겸하고 있으며, 서울디자인컨설턴트, 서울시 미래유산보존위원회 위원, 한국공예·디자인문화진흥원 '공공디자인으로 행복한 공간 만들기' 사업 총감독을 역임했다. 저서로는 『모든 장소의 기억』(문학동네, 2021), 『문화를 짓다』(문학동네, 2015), 『모던 스케이프』(이레, 2009), 『궁궐의 눈물, 백 년의 침묵』(효형출판, 2009) 등이 있다.

A Negative of Time

Park Sungjin
(Principal, Site & Page; former editor-in-chief,
SPACE)

1 This theoretical approach by Le Corbusier defined the basic structure of a building in terms of minimal columns and a floor that are separate from the walls. It went on to contribute in crucial ways to the industrialization and proliferation of modern architecture.

2 These flat floor structures, created by pouring concrete into slabs, are usually used to mark the divisions between stories.

What Was Lost and What Was Gained

The world both lost and gained certain things through the modern architecture that emerged around the 20th century. By declaring a break from tradition, modernism weakened regionality and sacrificed the time-honored aesthetics and design of architecture, its romance and expression. What did it gain in return? Architecture as industry, bigger and taller structures-and, more concretely, flat rooftop spaces to replace the old gabled roofs. Not only were these rooftops included in Le Corbusier's "Five Points of New Architecture," but they also contributed to the realization of the other points. Le Corbusier proposed liberating the earth from the structure through the use of pilotis, suggesting rooftop gardens as a form of "artificial earth" up in the sky. The "Dom-Inno System"[1] for which he advocated may have represented the fastest and most rational system for connecting the idealized earth and the rooftop.

MMCA Gwacheon Project 2022: Rooftop shares the same *signifiant* as the modern rooftop garden, but it starts from a place that presumes differences in the philosophy and *signifié*. We have already experienced the extent of the conflicts and issues created as the theories of modern idealists have reached beyond industry and production and come face-to-face with human emotions and lives. In that final moment after the flat slabs[2] were stacked to create the rooftop, what sort of space did it become for modern and contemporary urban lives? Occupied by complex machinery and the noise of contemporary architecture, it operated for the most part as a lower-level space, far removed from pedestrians and leisure. As they explore the ideals of modernity, architects continue to infuse rooftops with their pure spatial thinking, working with the expectation that building users-fundamentally cut off from the open air by curtain walls-will opt to use the rooftop over their heads. But without surrounding scenery and a view, consideration of the oft-present machinery, and guarantees about easy access and landscape, we have time and time again seen architects' intentions devolving instead into sorry smoking areas littered with cigarette butts.

Wasn't it this kind of modern thinking that informed the concept of the third-floor Rooftop at the National Museum of Modern and Contemporary Art, Gwacheon (MMCA Gwacheon) by architect Kim Tai Soo? I've visited MMCA Gwacheon dozens of times, and I only just now learned that there even is a Rooftop. Is it some sort of secret garden or empty space left neglected for safety and security reasons? In this way, the Rooftop project is a reflective consideration of the kinds of rooftop gardens that are spoken of by modern architecture, as well as the restoration of a space and a new approach to transform an idle space within the museum into a stage of sorts. The winning concept,

architect Lee Jeonghoon's *Garden in Time*, is likewise a space that blossoms emergently within the difference of *signifiés* between the modern and contemporary rooftop gardens. He was obliged to create a pluralized cultural landscape to suit the contemporary era, within the realm of reason and pure geometry that modern architecture has constructed.

In this sense, the most salient aspect of this year's Gwacheon Project is the given site. The first project's target site, the museum's Outdoor Sculpture Park, presented a decontextualized setting that allowed for various forms of architectural allegory and expression; the second project's Art Bus Shelter was more akin to three-dimensional sculpture, with only the minimum shelter role intervening. In contrast, this year's project provides the "artificial earth" setting of the rooftop, originating in the complex demands of having to rummage through the ideas of veteran architect Kim Tai Soo within a linear boundary that cannot cohere into a single whole.

How to Perceive Time's Formlessness

That being said, *Garden in Time* did not start as the antithesis of the meta-discourse of modernity. In fact, Lee Jeonghoon began conceiving the work out of very small phenomena and momentary experience. The architect has explained that he was inspired by the stainless steel railing placed around the third-floor Rooftop, which he saw while surveying the space in the project submission stages. Through a 1.2-meter-high railing installed purely for safety reasons, without any craft elements or individuality, he spied possibilities within this pure setting where building meets sky. Placed at 10-centimeter intervals, the bars of the railing briefly forgot their original role as safety structures and came together with the light, and Lee was there within the moment of that landscape. In point of fact, such railings contribute nothing to the perfection of a structure. This is why the railings in today's architecture sacrifice their craftsmanship, their very materiality gradually fading away as their structure and form are minimized. *Garden in Time* is a work created through the emotional amplification of the structure's micro-scale landscape. While its origins may have been inspired by the railing, there is a point where the work enters the realm of a space and structure that differ from a mere railing. How might we recognize and perceive time within it?

In Greek mythology, Chronos, the personification of time, had no inherent form. How can architecture ever capture the concept and abstraction of time, which exists without any form or substance? In such instances, it is neither particularly difficult nor very original for

an architect to think of light and shadow. Architects deal with space, and time for them is something that they must always be conscious of and confirm through the rising, lingering, movement, and fading of light. Lee's ideas about time and space can be seen in the following short statements from his proposal:

If time had a garden, what form would it take? Time within geometric space can only exist by endlessly erasing itself. This may be because it can only exist when it endlessly conceals itself within the solemnity of absolute space. (...) If time had materiality, in what form would it manifest? In this place, time reveals itself as a new form as it cuts across space. Time demonstrates itself through the shadows cast by light, through the three-dimensionality of their totality.

For architects, the matter of making the unseen visible ultimately comes down to questions of form. If the light and shadow used to construct *Garden in Time* represent the general solution, then Lee's special solution lies in the structure that dominates the Rooftop as a whole. What finally places the hitherto-unseen time in view is the geometric meeting between the vertical element of the bars and the horizontal element of the handrails. While it may seem at first glance that the vertical forms and bars leading from the railing would contribute more to making shadows, they are actually supported by four circular rings that are suspended to match the Rooftop's outer and inner diameter. Moreover, the rings are tilted at different angles, intersecting and overlapping to form different landscapes of time. The height of the bars varies with the slope in the rings, allowing visitors to walk through a garden of light that is at once afloat and submerged. The space of solemn geometry that once had to efface itself is deconstructed within this drama of light and shadow and rebuilt around the concept of "I" and the present "moment in time." Fissures and differences finally appear in the uniformity of the circle. Also, while it was not incorporated in any proactive way, the second-floor Circular Garden, visible from an opening in the middle of the third-floor Rooftop, adds an element of spatial depth to the garden's time, making us silently sense not the presence and flow of time, but its thickness and depth.

With the order he creates and varies here, Lee has devised a new experiential sequence for visitors. As we open the door and emerge into the Rooftop, the surrounding landscape alternately becomes obscured and opens up, tightening and broadening as it attunes to our movements. Our inward-directed gaze escapes outside; we look at geometry, only to eventually return to nature. Inside is the world of pure geography expressed by the Rooftop and its structure; outside is the surrounding scenery and natural world. As the dials of these two different worlds are turned-inside and outside, geometry and nature-

the result is a sensory experience induced in visitors.

I feel a sudden nostalgia for an imaginary moment: a winter morning when the railing's shadows stretched long and I was walking around the untrodden Rooftop, pushing myself briefly into the surrounding snowy landscape. In that moment, the time to come and the time that might pass would stop and wait for me. When the chilly wind blows against me, I would observe the negative of time inscribed on the floor. Once the space is vacated once again, a different landscape of time would arrive to fill the vacuum I have left.

Sensing Abstraction through Technology

Garden in Time may have begun from conceptual thinking, but the methods employed in the stage in which it was concretely realized were a thoroughly technologically based form of architectural production. The work was not installed at a particular point like an art object, nor did it have a drab composition in which the parts came together immediately to form the whole. Accordingly, it required technology in the production stage to closely connect the parts with the whole. This design, as well as other practical issues, would have been difficult to resolve without Lee's technology-oriented attitude and mathematical thinking.

In the work, the logic of the "part" completes the whole by means of mediating variables: ideal modeling based on mathematical thinking in a virtual world, and the current incompleteness of the Rooftop, which in the 1980s would have been constructed by craftspeople who relied on their instincts rather than measurements and numbers. The design methodology used to fill the discrepancy and divide between these two worlds employed Building information modeling (BIM) and real-world measurements based on 3D scanning. Without the tension structure designed through these precise calculations, we would never have seen the white beating of wings stretching 39 meters across, situated airily atop the Rooftop.

All of the materials designed using BIM were premade at a factory for swift assembly and installation on site. Lee has already experimented with this method of architectural production for the Pergola of The Club at NINE BRIDGES. He must have felt confident in this method, as he used BIM and factory production to build the irregular structure of the pergola using a steel skeleton and glass, a far more difficult approach than that of *Garden in Time*. This production method can be considered especially appropriate when we consider that the work is not a permanent installation, but will have to be taken down later on. It is a structure that can be produced quickly, installed conveniently,

3 A general term for ornamental roof coverings placed horizontally atop columns.

4 A form of gable used in ancient Greek and Roman architecture, these triangular decorations were connected to the top portion of the entablature.

Pergola of The Club at NINE BRIDGES ©Efrain Méndez (architecture: JOHO Architecture (LEE Jeonghoon))

Seolhaeone Clubhouse ©Efrain Méndez (architecture: JOHO Architecture (LEE Jeonghoon))

Eaves House ©Shin Kyungsub (architecture: JOHO Architecture (LEE Jeonghoon))

The Asymmetric House ©Roh Kyung (architecture: JOHO Architecture (LEE Jeonghoon))

and dismantled with ease. Because this project went beyond the level of an object and involved the entire rooftop space, a technical approach to the work's existential temporality in terms of production, installation, and dismantling was necessary.

The Thickness of Restoring Space

In the introduction, I talked about the flat rooftop as one of the things gained by modern architecture; conversely, this led to us losing the traditional roof. More precisely, what we gave up was the thickness of the roof. As modern architecture replaced the old roof with a thin flat slab, it erased the space's thickness, formativeness, and materiality. In Greek architecture, an entablature[3] and a pediment[4] were put in place before the roof was raised over columns; what rich artistic elements and embellishments architecture gained within that thickness of space. That very thickness was the key factor that granted architecture the status of an art form. Varying its character with the region's culture and climate, it was the hidden champion responsible for creating spatial abundance. In the case of Korean traditional architecture, we can understand this by considering the spatial thickness of the *gongpo* bracket design and eaves that were part of traditional roofs.

Looking at other work by Lee we can see his technical and conceptual efforts to restore the thickness of the lower spaces of the roof, which have degenerated under modern architecture. Of course, he is not immersing himself in aesthetic and artistic individuality and expression here as in the classical architecture. Instead, he focuses on something in between that is overlooked by contemporary architecture: the connection between nature and the interior. As with his experiments with light in *Garden in Time*, he has striven in his other architectural work to approach light and nature not through the conventional vertical windows, but through the roof and its lower-level spaces. In his recent design for the expanded and renovated Seolhaeone Clubhouse in Yangyang, he incorporated light and scenery by creating different roof slopes and thickness for each architectural mass while experimenting with a new presentation of the interior space. When one looks up at the windows in the roof from inside, a third sensory layer exists between the viewer and the sky. For the Eaves House in Gwacheon, Lee consciously presented a modern take on the roof and eaves in Korean traditional architecture; in this case, he created a contemporary surface on the lower portion of the eaves through the use of stainless steel pipes, similar to those found in *Garden in Time*. Within the thickness of these pipes, he experimented actively with air circulation and the introduction of light so that the structure could perform the function of a "passive house."

The vertical geometry and patterns that appear in his architecture are often the result of his considerations of how to integrate the lower spaces of these roofs with the building itself, or whether to keep them separate and individuated. The Asymmetric House in Wirye, a community in Gyeonggi-do, is another example of these lower spaces of a roof being accentuated through their distinctive sunken volume and shape.

From this standpoint, *Garden in Time* is a roof structure created by four rings with different slopes, so that each space has a different thickness value. Differences in light and shadow are formed through changes in the roof structure's thickness and height. If there is a difference between *Garden in Time* and Lee's previous architectural work, it is that the previous work was based on a positive perspective-in which the architect considered how to bring light into a space to fill it-whereas *Garden in Time* dematerializes that thickness, inscribing shadow on the space like a photographic negative.

Park Sungjin

As principal at Site & Page, Park Sungjin plans architecture and spaces and creates related content. He studied architectural theory and history at the Korea National University of Arts and the Universidad Politécnica de Madrid in Spain, using this experience as a basis for a wide range of activities that include spatial planning, design consulting, publishing, exhibiting, research, and education. Working as editor-in-chief of the monthly magazine *SPACE*, he established a network as well as gained experience and an overall perspective on contemporary architecture. He currently serves as president of Surreal Estate, and he has also worked as the Seoul Design Consultant, a member of Seoul's future heritage preservation committee, and general director of the project "Creating Happy Spaces through Public Design" at Korea Craft & Design Foundation. His publications include *The Memories of All Places* (Munhakdongne, 2021), *Building Culture* (Munhakdongne, 2015), *Modernscape* (Ire, 2009), and *Tears of the Palace, a Century of Silence* (Hyohyung Books, 2009).

동시대미술의 공공성에서 마라톤
이정훈 건축가 〈시간의 정원〉
〈시간의 정원〉

정영선(홍익대학교 예술학과 교수)

파빌리온 프로젝트로 유명한 미국의 미술가 댄 그레이엄(Dan Graham)은 "오늘날 [예술계에] 미술가들은 건축가가 되고 싶어하고 건축가들은 미술가가 되고 싶어하는 전염병이 돌고 있다"고 말했다. 이러한 흐름은 1960년대 이후 현대미술에서 간파되는 건축적 조각(architectural sculpture), 건축조각(archi-sculpture)이라는 새로운 동향을 만들어내며, 조각과 건축의 교차적인 만남을 강조하는 징표가 되고 있다. 이는 딜러 스코피디오+렌프로(Diller Scofidio+Renfro), 데이비드 아자예(David Adjaye), 페드로 레이에스(Pedro Reyes) 등의 사례를 통해 더욱 구체화되어 왔으나 최근에는 이러한 흐름이 생태학적 의미, 재생의 의미 등으로 확장되고, 기존에 있었던 미학적 요소들을 적극적으로 활용함으로써 유럽의 상황주의자들이 견지했던 전용(détournement)이 중요하게 부각되고 있다. 2022년 여름, 이정훈 건축가가 국립현대미술관 과천의 옥상정원에 설치하는 〈시간의 정원〉 프로젝트는 기존 건물 구조를 전적으로 변경하지 않는다. 오히려, 이미 존재하는 건축물과 공간을 기반으로 한 미학적 요소를 최대한 활용한다는 점에서 상황주의자들의 전용적인 요소가 부각되고, 근대적 공간이 지닌 기능주의 성격을 다소 해체하여 탑다운의 권위적인 방식에서 탈피하게 만든다.

전후 유럽의 상황주의자들에게 도시는 거대한 놀이터로, 그들은 전통적인 도시 계획과 고정된 형태와 영구적인 문제 해결 방안을 거부하였다. 오히려 '상황'을 새롭게 구축하여, 거리를 걷는 사람들, 공간을 산보하는 이들이 그 공간을 '표류'하게 하여 공간의 의미를 적극적으로 생산해 내는 주체적인 모습을 띠게 하였다. 파리, 런던, 뉴욕과 같은 대도시가 권력과 금융 거물들에 의해 좌지우지된다 하더라도 도시는 일상생활에 대한 효율적인 저항의 장소로서, 명상이나 소비라는 기호 체계를 보여주는 공간이 아닌, 버려지고 타락하며, 또 기능적이고 구조적이면서 '전문화된' 일상생활을 극복하는 '무엇인가'이다. 거대한 자본에 잠식되는 공간들은 이미 스펙터클로 기호화되어 버린 죽은 공간이지만, 〈시간의 정원〉에서 이정훈 건축가가 지향하는 바는 시간의 흐름에 따라 매번 달리 보이는, 일상성의 새로운 체험과 관람자들의 교감이 필요한 공간의 새로운 생산이다. 마치 미셸 드 세르토(Michel de Certeau)가 『일상생활 실천』(The Practice of Everyday Life)에서 설명한 것처럼, '걷기'는 반복적이고 무의식적인 행위가 반복되는 공간에서 도시 거주자들이 어떤 식으로 일상을 탐색하는지를 잘 보여준다.

그동안 과천프로젝트는 국립현대미술관 과천관이 위치한 정원이나 녹지 공간을 이용해서 건축 프로젝트를 다수 진행해 왔다. 특히, 2021년에는 예술버스쉼터 프로젝트를 통해 일시적으로 존재하는 '설치미술'과도 같은 프로젝트가 아니라, 다년간 사용 가능한, 지속 가능한 건축, 디자인 프로젝트로 확장하고자 하였다. 이는 미술계뿐만 아니라 팬데믹으로 인한 인류세 시대의 새로운 삶의 방식에 대한 인식과도 같이 가는 경향이라고 할 수 있다. 자연과 인간의 불균형으로 파생되는 팬데믹은 우리가 새로운 생태 조건들을 고민할 수밖에 없는 현실에 직면해 있음을 알려준다. 이정훈 건축가가 제안한 방식은 기존 옥상정원의 빈 공간을 활용하지만, 과도하게 스펙터클한 조각적 설치를 구현하지 않고 장소 순응적인(site-oriented) 교감을 강조하는 시선을 택한 듯하다. 이러한 〈시간의 정원〉은 영구적인 구축물로

존재하기보다는 몇 년 동안 지속될 수 있는 새로운 가능성들을 탐색하는데, 이는 최근 일시적인 전시에서 수반되는 수많은 쓰레기 배출량과 과도한 도록 제작 등으로 미술계가 지나친 '잉여'의 순간에 직면해 있는 문제와도 연관된 듯하다. 장소와 교감하는 작품은 자연을 지나치게 지배하려고 하거나, 미술관의 인공물을 지나치게 압도하려는 관계를 재고하게 한다. 〈시간의 정원〉이라는 제목 자체는, 자연과 주변 환경이 가진 시간성이 매 순간 옥상정원에서 느껴질 수 있도록, 변화하는 사계절과 하루 24시간의 흐름을 미시적으로 파악하려는 프로젝트임을 의미한다.

그동안 공간의 구축 자체는 정부나 기업 등 거대 조직이 기획한 제도적인 '전략'(strategies) 안에서 기능 중심으로 배치되었고, 여기에서 참여자인 우리는 수동적인 행동을 취하는 이들이었다. 그 장소에 적극적으로 개입하거나 참여하기보다는 방관자로서 주변부 인물이었다면, 〈시간의 정원〉에서 우리는 공간의 의미를 만들어내는 생산자로 새로운 자격을 부여받는다. 그리고 공간을 활보하는 사람들은 전략 속에 존재하는 조직적인 형태에 다소 저항할 수 있는 새로운 '전술'(tactics)을 사유할 수 있다. 과천관은 서울관에 비해 훨씬 더 넓은 공간을 확보할 뿐 아니라 주변의 자연 녹지와 함께 어울리는 새로운 장소의 의미를 부여받게 된다. 또한 옥상정원에 하나의 새로운 쉘터처럼 설치된 조형물은 사람들이 변화하는 자연과 함께, 그림자의 위치, 산책 등과 적극적으로 반응하게 한다. 늘 있었던 공간을 새롭게 인식하고 이 공간을 일상적으로 걷는 참여자들이 바로 일상생활의 새로운 '실천자'들이다.

건축가로서 교육을 받았지만 이후 현대미술 작가로 더 많이 활동했던 고든 마타-클락(Gordon Matta-Clark)은 이러한 공간을 걷는 이들을 '방랑자들'(Wandersmänner)이자 표류자로 불렀다. 이번 팬데믹 이후에 또 다른 팬데믹이 오지 않으리라는 보장은 없다. 해외여행은 언젠가 '가능'해지겠지만, 세계화 당시의 글로벌한 자유로움에 대해서는 오늘날 다시 한번 생각하게 만든다. 이 점에서 〈시간의 정원〉은 마타-클락의 반건축이 했던 것처럼 우리에게 '인류학적이고, 시적이며, 신비로운 공간을 경험'하게 할 것이다.

과천관 옥상정원에 설치되는 〈시간의 정원〉은 건축적이면서도 조각적인 건축물을 진행했던 그레이엄이 뉴욕 첼시의 디아 센터(Dia Center)에 설치했던 작품과 비교해 볼 수 있다. 그레이엄의 〈옥상 도시 공원 프로젝트〉(Rooftop Urban Park Project, 1991)는 사각형의 유리 파빌리온으로, 윗부분이 뚫려있고, 그 안에는 원형 유리 구조물이 존재한다. 두 작품 모두 공간의 투명성을 강조하는 동시에 20세기의 대표적인 건축 재료들을 이용한다. 디아 센터의 옥상에 설치되었던 투명한 유리와 거울 파빌리온을 본 당시 관객들은 (1991년 당시만 해도) 창고와 차고지밖에 없던 첼시의 슬럼 지대와 폐허였던 고가 철도 하이 라인(High Line)을 관람할 수 있었기 때문에, 그레이엄의 작품은 오늘날 기준에서 재생의 의미와 공공조각으로서의 의미를 동시에 띤다.

〈시간의 정원〉은 구성 자체를 보면 원형 금속 파이프를 이용하였는데, 파이프가 공간 속에서 채워지고 비워지는 '음양'의 운율을 형성한다. 파이프 배열 자체도 동선에 따라 형태가 점차 커져나가게 되는데, 이때 관람자의 움직임 자체가 공간 경험에 있어서 중요한 조형 요소로 반영된다. 작품은 그곳에 설치돼 있지만, 한곳에서 파노라마식으로 관람할 수 있는 것이 아니라, 관람자가 위치한 장소에 따라 각기 다른 건축적/조각적 풍경을 느낄 수 있다. 이것은 조각과 관람자의 현상학적 조우에 따라 구축되는 새로운 감각의 경험이다. 가벼운 느낌을 강조하는 파이프들은 공간에서 조립됨으로써 전시 이후에도 조립식으로 해체되는 완결성을 띠게 하였다. 공간 내에서 일종의 코어로 존재하는 것이 아니라 새로운 부분으로 존재하며, 이러한 부분은 전체 속에 놓일 때 의미가 만들어지는 '부분적 대상'일 것이다. 또한 〈시간의 정원〉 구축물이 보여주는 캐노피 같은 형식은 마치 그 자체가 하늘에 부유하는 듯한 착시적 양상을 띠기도 한다.

오늘날 동시대미술에서 우리는 예술과 생태를 다시 한번 사유하게 된다. 이것은 팬데믹 상황이 장기화하면서 일어난 현상이기도 하지만, 2010년대 이후 우리 사회가 멈출 수 없는 가속도로 앞으로 나아가는 현상에 대한 일종의 반성과도 같이한다. 2014년 니콜라 부리오(Nicolas Bourriaud)가 타이베이비엔날레 전시 제목으로 사용한 '극렬가속도'처럼, 우리는 우리의 환경과 생태를 새로운 관점에서 생각해 보게 된다. 펠릭스 가타리(Félix Guattari)는 일찍이 『세 생태학』(The Three Ecologies)을 기술하면서 생태학에서 바라본 자연 중심의 시각에서 새로운 관점의 전환을 유도하였다. 그는 사회적 관계와 인간의 주체성, 그리고 환경적인 문제까지도 포괄하는 유기적 관점을 옹호하는 시각으로 우리의 사유가 확장되길 바랐으며, 특히 기술 문명도 에콜로지 내에서 바라볼 것을 촉구했다. 우리는 테크놀로지를 포기하고 루소의 '자연관'으로 돌아갈 수 없는 21세기 인류세 시대에 살고 있기 때문에, 〈시간의 정원〉도 자연(환경)-작품[인공품(artifact)]-테크놀로지의 관계를 비껴갈 수 없다.

현대미술에서는 장소 그 자체가 중요한 의미를 띠는 장소특정형 작품들이 많이 설치되어 왔기 때문에, 〈시간의 정원〉도 장소성을 기반으로 한 현대미술의 맥락과 같이한다고 볼 수 있다. 하지만 그보다 중요한 것이, 자연과 인간, 그리고 테크놀로지 기반으로 만들어진 건축적 조각은, 기술이 이제 인간에게 피할 수 없는 신체 일부라는 것을 분명히 보여준다. 자연과 환경이 중요하지만, 우리는 도시나 도시의 인프라 구조를 완전히 벗어나 살 수 없다는 사실 또한 이번 팬데믹 동안에 분명해졌다. 그렇다면 건축적 조각이 자연의 일부로서, 자연과 함께, 자연과 교감하는 새로운 방식으로 공간을 점유해야 한다는 것이다. 또한 자연을 위협하거나 우리의 시각을 위협하는 권위적인 방식을 거부하고, 수평적이며 관람자들의 몸을 자유롭게 포용하는 공간 구조로 자리매김해야 한다. 이러한 관점에서 〈시간의 정원〉은 다른 작품들에 비해서 관람자들의 시각을 바탕으로 한 "경험주의적" 현상학적 프로젝트로 설명될 수 있다.

재생적 관점에서 보자면, 생태학은 지난 수십 년간 신자본주의의 독점화와 환경 문제로 인해서 완전히 붕괴되어 버렸다. 이는 모든 생명 시스템을 다시 한번 되돌아보게 하고, 환경과 인간, 사회적 체계까지도 재논의해야 할 위기의식을 태동시켰다. 물론 이러한 변화된 시각은 현재까지도 우리 삶에 영향을 미치는 팬데믹과 연관된다. 20세기 건축적 조각이 보여준 유토피아적 시각보다 현재 시도되는 이러한 건축적 조각 프로젝트가 생태학과의 관계망 속에 인간의 삶과 주변 환경, 그리고 우리의 주체적 의식을 재고하게 하는 데 훨씬 더 많은 관심을 두고 있다. 그것은 '사변적 실재론'(speculative realism)적 관점으로, 모든 살아있는 생명체가 이루는 유기적 네트워크, 즉 순환적인 사이클과 관계망에 대한 생태학적인 논의를 불러일으킨다. 〈시간의 정원〉은 이러한 시각적 프레임 안에 자리 잡으며, 우리의 일상성 속에 새로운 감각을 불러일으키는 예술 작품으로 작동한다.

정연심

정연심은 홍익대학교 미술대학 예술학과 교수로 재직 중이며, 2005년 뉴욕대학교
미술사학과(Institute of Fine Arts)에서 박사 학위를 취득했다. 이후 뉴욕주립대학교 FIT의
미술사학과에서 조교수를 역임했다. 1999년 뉴욕 구겐하임미술관에서 개최된 백남준
회고전에 리서처로서 참여하는 등 뉴욕에서 리서치 베이스 기획자이자 연구자로
활동했다. 2014년 광주비엔날레 특별전에 공동 큐레이터로 참여했고, 2018년엔
광주비엔날레 공동 큐레이터로서 《Faultlines》를 기획했으며, 최근엔 《2021 DMZ Art
& Peace Platform》의 총감독을 역임했다. 2013년 비평가 이일 앤솔로지(미진사)를
편집했으며, 이후 공동 에디터로 프랑스(Les Presses du réel, 2018)에서 이
책을 출판하였다. 저서로는 『현대공간과 설치미술』(에이엔씨, 2014), 『한국의
설치미술』(미진사, 2018) 등이 있다. 2018-2019 풀브라이트 펠로우로 뉴욕대학교 대학원
미술사학과에서 방문연구교수를 역임했고, 2020년 저자이자 공동 에디터로 *Korean Art
from 1953: Collision, Innovation, Interaction* (London: Phaidon)을 출판했다.

Lee Jeonghoon's *Garden in Time* from a Contemporary Art Perspective

Chung Yeon Shim
(Professor, Department of Art Studies at Hongik University)

Dan Graham, a US artist famous for his pavilion projects, once commented that a "disease" was going around the art world of his day: namely, that artists all wanted to be architects and architects all wanted to be artists. That current gave rise to a trend visible in contemporary art since the 1960s-"architectural sculpture" or "archi-sculpture," a symbol emphasizing the intersection between sculpture and architecture. The concept was fleshed out even further by figures such as Diller Scofidio+Renfro, David Adjaye, and Pedro Reyes. But as the current has recently broadened with ecological meaning and regenerative meaning, it has begun actively incorporating aesthetic elements that were already present in a given setting, assigning key prominence to the kind of *détournement* advocated for by the European Situationists. *Garden in Time*, a project by architect Lee Jeonghoon that will be installed in the summer of 2022 in the Rooftop of the National Museum of Modern and Contemporary Art, Gwacheon (MMCA Gwacheon), does not attempt a full-scale transformation of the museum's existing architectural structure. If anything, it makes maximum use of the preexisting structure and space's aesthetic elements. In that sense, it emphasizes the same *détournement* elements as the Situationists while enabling a departure from an authoritarian "top-down" approach through its deconstructions of the modern space's functionalist character.

To the Situationists of postwar Europe, the city was a large playground. They rejected traditional urban planning, fixed forms, and permanent solutions. Instead, they created new "situations" that assigned a more subjective role to the people walking through the city's streets and spaces, causing them to "drift" in their settings and thus more actively generate spatial meaning. Even in the cases of major cities like Paris, London, and New York, which are dominated by powerful figures and plutocrats, the city is a place of efficient resistance against everyday life: not a setting in which to showcase the symbolic systems of meditation or consumption, but "something" to transcend aspects of everyday life that have been abandoned, degraded, or else functional, structural, and "specialized." Corroded by vast wealth, these spaces are already "dead," signified in terms of spectacle. What Lee Jeonghoon poses with *Garden in Time* is the creation of a new space that appears constantly different with the passage of time, one that necessitates a new experience of the everyday and a communion on the part of the viewers. As Michel de Certeau explains in *The Practice of Everyday Life*, the act of "walking" offers an excellent illustration of how city dwellers seek out everyday life in spaces characterized by repetition of repetitious and unconscious actions.

Previously, the MMCA Gwacheon Project has largely consisted of architectural projects making use of the gardens and greenspaces of the museum. In particular, the Art Bus Shelter Project in 2021 was

an attempt to broaden its scope to sustainable architecture and design projects that could be used for years, rather than "installation art" projects that would remain in place only briefly. Beyond the art world, this trend is oriented similarly with the new perceptions of our ways of life in the Anthropocene epoch that have been prompted by the pandemic. With its origins in imbalances between nature and humankind, the pandemic shows us that we are facing a reality in which we must consider new ecological conditions. Lee's suggested approach makes use of the existing empty space of the MMCA Gwacheon Rooftop, but instead of creating a sculptural installation that would have been excessively "spectacular," the architect seems to have opted for a perspective that emphasizes site-oriented communion. Rather than existing as a permanent structure, *Garden in Time* explores new possibilities that can remain in place for a few years-an approach that also relates to problems recently faced by the art world in an era characterized by surplus, including large volumes of trash generated by one-time exhibition events and excessive catalog production. Through its communion with its setting, the work reconsiders relationships that involve overreaching attempts to dominate nature or to overwhelm the museum's artificial elements. The title *Garden in Time* itself signifies a project that seeks a fine-grained understanding of the changing course of the four seasons of the year and the 24 hours of the day, so that the temporality of nature and the surrounding environment can be felt in the Rooftop from one moment to the next.

In the meantime, spatial structures have been focused on function within institutional "strategies" devised by large-scale organizations such as governments and corporations; the rest of us have been passive participants. This peripheral observer role does not allow for active involvement and participation in the space, but in contrast, *Garden in Time* assigns viewers a new role as producers creating the space's meaning. Moreover, the people walking through the space can also contemplate new "tactics" for resisting, in a sense, the organizational forms that are present within those institutional strategies. Not only does MMCA Gwacheon ensure a much larger space than MMCA Seoul, but it also assumes new meaning as a setting that melds with its surrounding natural greenery. Additionally, Lee's structure, positioned like a new shelter within the Rooftop, encourages people to actively respond to the changing nature, the movement of the shadows, and the act of strolling alongside the changing natural environment. Forming new perceptions of a previously existing space as they walk through the setting, participants become new "practitioners" of everyday life.

Trained as an architect but more active as a contemporary artist, Gordon Matta-Clark referred to people who walk through spaces

like this as *Wandersmänner* or "drifters." We cannot be certain that another pandemic will not follow once the current one is over. It may become "possible" for us to travel overseas again but the situation today forces us to give renewed thought to the boundless freedom of the era of globalization. In that sense, *Garden in Time* encourages us to have an "anthropological, poetic, and mythic experience of space" just as Matta-Clark's "anarchitecture" did.

Placed in the MMCA Gwacheon Rooftop, *Garden in Time* may be compared with the artwork Dan Graham presented at the Dia Center in New York's Chelsea neighborhood. Graham designed structures that were both architectural and sculptural, and in the case of his *Rooftop Urban Park Project* (1991), the structure was a rectangular glass pavilion with an open roof and a circular glass structure inside. Both Lee's and Graham's works emphasize the transparency of the space, while employing the representative architectural materials of the 20th century. Because Graham's glass and mirror pavilion drew in visitors who would also experience the view of the Chelsea slum that consisted (at least in 1991) of only warehouses, depots, along with the derelict elevated railway known as the High Line, the work held significance as both a "regeneration" and a "public sculpture" by today's standards.

In terms of its composition, *Garden in Time* makes use of round metal pipes, forming a rhythm of yin and yang through the presence and absence of pipes filling the space. The shape of the pipes' arrangement gradually increases in size as visitors walk along, so their movements become reflected as key aesthetic elements in the spatial experience. While the work has a fixed position, it cannot be viewed panoramically from any one viewpoint; instead, viewers can perceive it as an architectural/sculptural landscape that differs depending on where they are located. It is a new sensory experience created through the phenomenological meeting between sculpture and viewer. With their lightweight quality accentuated, the pipes assume completeness through assembly at the location, and can also be disassembled once the exhibition is complete. Rather than existing as a kind of "core" within the space, the work is present as a new component of it, possibly signifying a "partial object" whose meaning is created as the component is situated as part of a whole. The canopy-like shape that *Garden in Time* provides also assumes an illusory quality, seeming to float in the sky on its own.

In today's contemporary art environment, we find ourselves thinking once again about art and ecology. This phenomenon has emerged in part because of the persistent pandemic, but it also relates to a kind of reflection on social phenomena since the 2010s, as society seems to be racing ever-forward in an endless acceleration. As suggested

by the 2014 Taipei Biennial's title *The Great Acceleration* (selected by Nicolas Bourriaud), we have begun to consider our environment and ecology from a new standpoint. Writing about *The Three Ecologies*, Félix Guattari encouraged a shift toward a new, nature-centered viewpoint through the lens of ecology. He hoped to see human ideas broadening into a perspective that advocated for an organic perspective encompassing environmental issues alongside societal relationships and human subjectivity; in particular, he called for us to view technological civilization in ecological terms. Living as we are in the Anthropocene epoch of the 21st century, in which we do not have the option of abandoning technology and returning to nature as Rosseau viewed it, the relationship among nature (environment), artwork (artifact), and technology is an unavoidable connection within *Garden in Time* as well.

In contemporary art, many site-specific artworks in which the setting itself takes on an important meaning have emerged. *Garden in Time* can likewise be seen as sharing this context with locality-based contemporary art. More crucially, however, architectural sculptures based on nature, humans, and technology have made it clear that technology is now an inextricable part of the human body. Through the pandemic, it has become clear to us that even with the importance of nature and the environment, we cannot fully leave behind the city or live outside of its infrastructure. In that sense, architectural sculpture must occupy space in a new way: with nature, as a part of nature, and communing with nature. It must be present as "horizontal" spatial structures that freely accommodate visitors' bodies, repudiating more authoritarian approaches that endanger nature and imperil our perspective. Viewed along these lines, *Garden in Time* can be described as an "empiricist" phenomenological project that is more rooted in the perspective of viewers than other entries.

From a perspective of "regeneration," ecology has been utterly devastated by capitalist monopolization and environmental issues over the past decades. This has forced us to reflect anew on all systems of life, awakening a sense of alarm and the need for renewed discussions on the environment, humankind, and social systems. This altered perspective obviously bears some relation to the pandemic, which continues to affect our lives even now. The current architectural sculpture project-in contrast with the utopian perspective of architectural sculpture in the 20th century-is much more interested in human lives and their surrounding environment in relation to ecology and in reconsideration of our subjective consciousness. It takes a perspective of "speculative realism" that encourages an ecological discussion about the cycles and relationships of the organic network formed by all living things. Within this visual frame, *Garden in Time* is

situated, operating as a work of art that awakens new perceptions in our everyday experiences.

Chung Yeon Shim

Chung Yeon Shim is a professor of the Department of Art Studies at Hongik University. She earned a doctoral degree from the Institute of Fine Arts at New York University in 2005, going on to work as an assistant professor in the Department of Art History at the Fashion Institution of Technology (FIT) at SUNY. While in New York, she worked as a research curator and researcher, and took part as a researcher in the 1999 Paik Nam June retrospective at the Guggenheim Museum. She participated as co-curator for a special exhibition at the 2014 Gwangju Biennale; she also co-curated *Faultlines* for the 2018 Gwangju Biennale; and recently she served as the general director of *2021 DMZ Art & Peace Platform*. She edited an anthology on critic Lee Yil (Mijinsa, 2013), after which she worked as co-editor on the book's French release (Les Presses du réel, 2018); and she authored the books *Installation Art in Contemporary Space* (A&C, 2014) and *Korean Installation Art* (Mijinsa, 2018). She worked as a visiting research professor in the Department of Art History at the New York University's Graduate School as a Fulbright fellow between 2018 and 2019; and in 2020, she took part as author and co-editor in the publication of *Korean Art from 1953: Collision, Innovation, Interaction* (London: Phaidon).

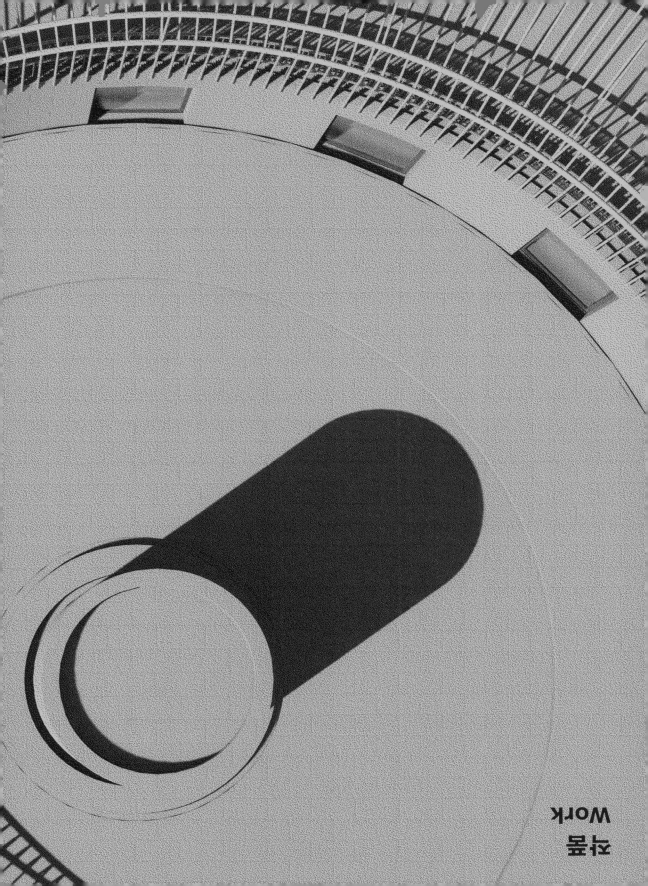

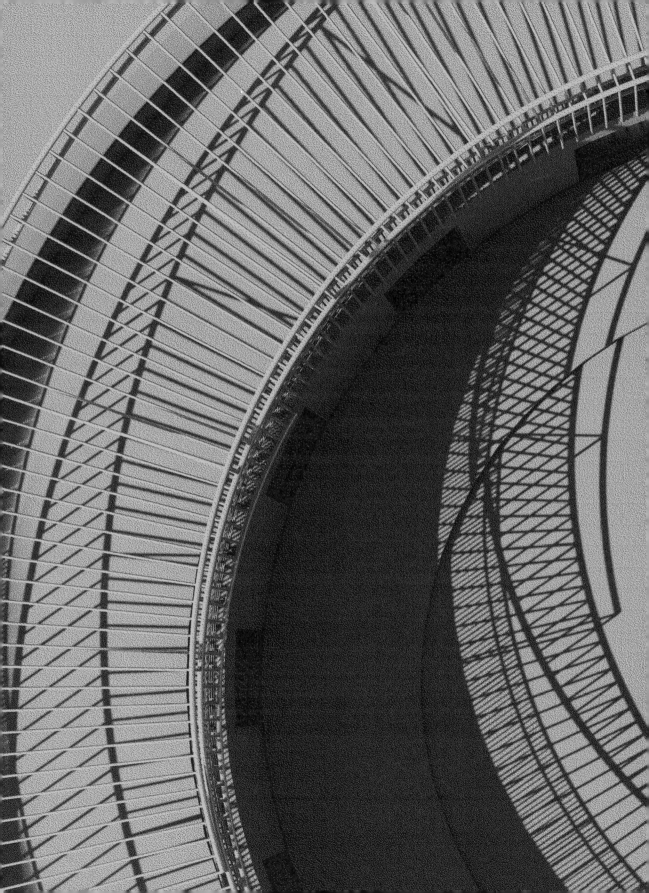

시간의 정원 Garden in Time

이정훈(조호건축)

Lee Jeonghoon
(JOHO Architecture)

시간의 정원

이정훈(조호건축)

Garden in Time

Lee Jeonghoon (JOHO Architecture)

성장하는 핸드레일

핸드레일이 성장하면 어떤 형체를 지닐까? 현장에 처음 방문했을 때 옥상에 설치된 핸드레일이 유독 인상적이었다. 90cm 높이의 건축 파라펫 위에 30cm가량 스테인리스 핸드레일이 덧붙여져 있었는데 아마 법규의 변화에 따라 핸드레일을 증축한 것으로 생각되었다. 이를 덧붙이기 위해 석재 패턴에 맞춰 1m 간격으로 핸드레일이 배열되었고, 이는 일정한 리듬으로 옥상의 이색적인 풍경을 만들었다. 만약 시간성을 두고 덧붙여진 핸드레일이 더 자라나서 이 공간이 입체적으로 성장한다면 어떠한 형상으로 드러나게 될까? 이는 현장의 물성에서 찾은 물음이었고 이 프로젝트의 시작점이었다. 기존 핸드레일의 성장이 법적 규정에 의해 어쩔 수 없이 해야만 했던 이차원적 진화였다면, 삼차원적으로 성장한 핸드레일은 기존 공간에 깊이를 더할 수 있을 것이라 생각하였다.

Growing Handrails

If handrails could grow on their own, what kind of shape would they take? From my first visit to the project site, the handrails on the Rooftop of the National Museum of Modern and Contemporary Art, Gwacheon (MMCA Gwacheon) were particularly memorable. Stainless steel and about 30 centimeters high, they were installed on top of 90-centimeter-tall parapets around the Rooftop, presumably as a later add-on following changes in safety regulations. To attach the rails, bars were placed on the parapets in one-meter intervals to match the pattern of the building stones, which created a certain rhythm that culminated in a unique landscape. If the handrails, installed as an extension to the building after a gap in time, could grow and three-dimensionally extend the Rooftop with them, into what kind of shape or form would they develop? This was the question posed by the physical properties of the project site and also the impetus behind the project as a whole. If the existing handrails

1-3 조호건축, 〈시간의 정원〉, 2022, 컨셉 스케치. ⓒ조호건축(이정훈)
JOHO Architecture, *Garden in Time*, 2022, concept sketches.
ⓒJOHO Architecture (LEE Jeonghoon)

73

열림과 닫힘으로서의 풍광 장치

만약 핸드레일이 입체적으로 성장한다면 열림과
닫힘의 시퀀스에 의해 구성된 조망 장치가 되어야만
했다. 역설적이게도 기존 건물의 옥상은 기획된 공간이
아니라 우연히 열린 의도되지 않은 외부 공간이었다.
이로 인해서 풍광의 열림과 닫힘, 동선에 따른 시퀀스의
연결이 없었고 전면에 펼쳐진 경관의 심상을 극대화하지
못하였다. 풍광 장치란 의도되지 않은 공간에 기획된
시퀀스와 심상을 제공하는 것을 의미한다. 제안하고자
하는 풍광 장치는 크게 외경과 내경의 원으로 구성된다.
외경의 원은 옥상에서 내려다보이는 미술관 지붕 면을
최대한 가리고 전면의 청계산과 관악산을 극적으로
보여주는 라인이다. 외경은 닫힌 구조로 시작하여 전면에
펼쳐진 조망점에서는 극적으로 열린다. 또한 하부를
지탱하는 구조 부재 없이 캔틸레버 그 자체의 긴장감으로
전면 풍광을 비장하게 드러낸다. 내경의 원은 외경의
원과는 반대 방향으로 열린다. 진입 축에서 하부의
원형정원을 바라보게끔 계획되었고 동선의 전개와
더불어 닫힌 구조로 바뀐다. 즉 외경과 내경의 열림과
닫힘 구조가 반대로 전개되는 것이다.

were a result of the two-dimensional evolution
the building inevitably underwent due to safety
regulations, I thought that a new set of handrails,
as a result of three-dimensional growth, could
add depth to the existing space.

A Scenic Device that Opens and Closes

If the handrails were to grow three-dimensionally,
they would have to take the form of a scenic
device that embodies an opening and closing
sequence. Ironically, the Rooftop of the museum
building was not a specifically designed space
but an exterior that happened to be left open.
Thus, it had no intended correlation to how
visitors move through it or are exposed to the
surrounding landscape, as it failed to magnify the
imagery of the scenery that unfolds before it. A
"scenic device," in this sense, imbues indeliberate
space with a deliberate sequence and imagery.
And the scenic device I propose is a large annulus,
comprised of an inner ring and an outer ring. The

74

4-5 조호건축, 〈시간의 정원〉, 2022, 컨셉 스케치. ⓒ조호건축(이정훈)
JOHO Architecture, *Garden in Time*, 2022, concept sketches.
ⓒJOHO Architecture (LEE Jeonghoon)

6-8 조호건축, 〈시간의 정원〉, 2022, 렌더링 이미지. ⓒ조호건축(이정훈)
JOHO Architecture, *Garden in Time*, 2022, rendered images.
ⓒJOHO Architecture (LEE Jeonghoon)

75

시간의 정원
Garden in Time

구조적 관계성, 그 자체로서의 형체

두 개의 원, 외경과 내경은 각기 다른 시퀀스에 의해 열림과 닫힘의 방향을 달리한다. 이런 두 개의 방향성을 가지는 원을 하나의 구조체로 엮고 그 자체로서 힘을 전달할 수 있다면 어떠한 형체가 될 것인가? 성장하는 핸드레일의 입체적 프레임을 구조적 형태로 연결하는 것은 공간의 완결성을 만드는 것뿐 아니라 기존 건축물과의 조화를 꾀하는 유일한 방법일 수 있다. 즉 하단을 지지하는 기둥 없이 외경의 호를 크게 열어젖히기 위해서는 상부에서 인장력으로 당기는 일종의 돛 형태의 구조적 해결책이 필요하였다. 외경과 내경을 연결하는 루버 프레임 위에서 캔틸레버 형태로 구조를 지지하는 건축적 돛, 일정 마스트(mast)들을 연결하여 장력 체계로서 구조체를 형성하고자 한 것이다. 이는 형태 그 자체로서의 구조, 구조 그 자체로서의 형태를 의미한다. 인장 관계로 연결된 형태는 그 자체로 긴장감을 형성하고 구조적 부재들을 단순한 형태감으로 구성함으로써 완결성 있는 공간미를 드러낸다. 이는 각각의 원형 파이프가 단순히 치장재로서가 아니라 인장재로서 역할을 수행함을 의미한다. 부재들은 각각의 구조적

outer ring is tilted to mask as much of the roof of the museum as possible and open up towards the view of the Cheonggyesan and Gwanaksan Mountains. It starts out as a closed structure and opens up dramatically at a viewpoint that faces the mountains. With no framework supporting the structure from below, the cantilever heroically reveals the landscape on its own, relying solely on systematic tension within the structure. The inner ring is tilted to open up in the opposite direction, so that when people enter the Rooftop, they are guided to look down at the Circular Garden on the second floor visible through an opening in the middle of the roof. This structure gradually closes as viewers move away from the entrance. In other words, the inner and outer rings alternately open and close.

Structural Relationship as a Form of Its Own

The two rings, each oriented inward and outward, operate on different opening and closing

9-12 조호건축, 〈시간의 정원〉, 2022, 렌더링 이미지. ⓒ조호건축(이정훈)
JOHO Architecture, *Garden in Time*, 2022, rendered images.
ⓒJOHO Architecture (LEE Jeonghoon)

긴장 속에 존재하며 각자의 역할에서 하나의 형체를
만들어낸다. 그것은 디자인과 엔지니어링 사이에서
형성해 낼 수 있는 구조미의 결정체이다.

디지털 기반의 수공예적 완성품

프로젝트 여건상 현장에서 조립, 용접하지 않고
공장에서 제작 후 현장 조립의 과정으로 전개하는 것이
합리적이었다. 특히 원형 금속 파이프를 각기 다른
각도로 배열하여 원형 파고라를 형성하면 밀리미터
단위로 세밀한 접합점의 차이가 존재하게 된다. 기존의
현장 제작 방식으로는 오차를 감당할 수 없을뿐더러
정교한 시공이 불가능하다. 현장 시공을 최소화하고
오차율을 낮추기 위해서 현장 3D 스캐닝을 바탕으로
BIM(Building information modeling) 방식으로 설계,
시공하였다. 즉 기존 공간을 완벽히 스캔함으로써
현장에서 변형해야 하는 파이프 간 조합 오차율을 제어할
수 있는 것이다. 이러한 데이터를 바탕으로 공장에서
모든 유닛을 제작, 검수하고 현장에서는 최단 시간에
조립 및 용접함으로써 생산 단가 및 공사 기간을 조절할

sequences. If we consider the two rings with
two different directivities to be woven into one
structure that has an impact on its own, what
kind of form does this structure take? Weaving
the three-dimensional frame of the growing
handrails into a structure isn't just the only way
to imbue the space with a sense of completion
but also the railing's only chance at achieving
harmony with the existing architecture. In other
words, for the outer ring to open up widely
without pillars to support it from below, a sort of
sail-like tension pulling it from above is needed
as a structural solution. Hence, I sought to attach
masts-architectural sails-to the louver frame that
connects the inner and outer rings. The masts will
support the structure in the form of a cantilever
and establish a system of tension, as well as
allow the formation itself to become the structure
and vice versa. The tensive connection as a
formation creates tension in and of itself, making
the framework feel like a simple form to render
a completed spatial aesthetic. In this setting,
each of the round pipes serves not as a mere

13 조호건축, 〈시간의 정원〉, 2022, 구조 부재 유닛(마스트).
ⓒ허브구조엔지니어링
JOHO Architecture, *Garden in Time*, 2022, structural unit (mast).
ⓒHub Structural Engineering

14 조호건축, 〈시간의 정원〉, 2022, 모델링 이미지(유닛상세). ⓒ조호건축(이정훈)
JOHO Architecture, *Garden in Time*, 2022, modeling image (unit detail).
ⓒJOHO Architecture (LEE Jeonghoon)

15 조호건축, 〈시간의 정원〉, 2022, 3D 스캐닝 이미지. ⓒ바른비아이엠스틸
JOHO Architecture, *Garden in Time*, 2022, 3D scanned image.
ⓒBarun BIM Steel

수 있다. 궁극적으로 유닛의 공장 제작 방식을 이해하고, 현장 설치 시 발생하는 오차를 디지털 기반 작업으로 제어함으로써 수공예적 예술 작품을 합리적인 방식으로 제작할 수 있는 것이다.

시놉시스: 시간의 정원

시간에 정원이 있다면 그것은 어떠한 형체일까? 기하학적 공간 속 시간이란 자신을 무한히 소거함으로써만 존재할 수 있다. 그것은 절대 공간이 지닌 엄숙함 속에 자신을 무한히 숨겨야만 자신이 존재할 수 있기 때문일 것이다. 이러한 면에서 자연은 공간 속에 시간을 드러내 주고 그 존재를 각인하는 매개체일 것이다. 만약 시간에 물성이 있다면 그것은 어떤 형태로 드러날 것인가? 이곳에서 시간은 공간을 가로지르며 새로운 형체로 자신을 드러낸다. 시간은 빛에 의한 그림자로, 그것들 총합의 입체로 자신을 증명해 낸다. 자연의 무한한 변화 속에 시간은 빛과 그림자의 연속으로서 이곳 정원에 자신을 펼쳐낸다. 그것은 이곳을 마주한 사람의 기억 속에서나, 시간의 풍광과 마주친 관념 속에서 공간의 찰나가 지닌

decorative element but as a tension member. The framework exists in its structural tension to serve a role in the constitution of a single form. This is the pinnacle of the structural aesthetic achievable through the balance between design and engineering.

Craftwork Completed on Digital Foundation

Given the conditions of the project, it made more sense to produce module units at a factory, then assemble them on-site, than to construct and weld each part directly at the museum. Especially when producing a circular pergola out of round metal pipes by setting them at different angles, the junctions are bound to be misaligned by millimeter-scale errors. On-site construction isn't the best methodology for this kind of meticulous work that allows no room for error. To minimize the need for on-site construction and the risk of error, I designed and produced module units based on 3D scans of the site and using the

Winter Daylight 9H
Winter Daylight 11H
Winter Daylight 13H
Winter Daylight 15H

16-19 조호건축, 〈시간의 정원〉, 2022, 렌더링 이미지 (겨울철 시간대별 빛 변화 시뮬레이션). ⓒ조호건축(이정훈)
JOHO Architecture, *Garden in Time*, 2022, rendered images (a simulation of light change over time during winter). ⓒJOHO Architecture (LEE Jeonghoon)

시간성을 보여준다. 이곳은 공간의 한편에 존재하는 시간이 아닌 순간의 연속으로서 시간의 존재를 오롯이 보여주는 장소이다.

Building information modeling (BIM) method. By perfectly scanning the existing site, it is possible to control the rate of errors that occur in the process of combining the pipes, which will need to be modified on-site. This way, the modules can be collectively produced and inspected at the factory based on data, and the time spent on assembly and welding at the museum can be cut down to save production costs and construction time. Understanding the production process and controlling potential on-site errors in installation through digital means ultimately allows for an artwork of handcrafted nature to be produced in a logical manner.

Synopsis: Garden in Time

If time had a garden, what would it look like? Time in geometric space can exist only by perpetually erasing itself. This is because time would have to perpetually hide within the solemnity of absolute space to be able to exist. In this sense, nature would be the medium that reveals time and imprints its existence within space. If time had a physical property, how would it be revealed? Here, time traverses space as it reveals itself in new forms. It proves its existence in the form of the shadows cast by light and the dimension created as the result of the sum of light and shadows. Amidst ever-changing nature, time unfolds itself across the garden in the form of a continuum of light and shadows. Both in the memories of the witnesses as they enter the time-scape, and in their minds upon confronting it, the garden demonstrates the temporality harbored by its space at that moment. As such, the Rooftop becomes a place that faithfully attests to the existence of time-time as something that exists not in one corner of a space, but as a continuum of moments.

20-21 조호건축, 〈시간의 정원〉, 2022, 모형 사진.
ⓒ조호건축(이정훈) (사진: 홍철기)
JOHO Architecture, *Garden in Time*, 2022, model photos.
ⓒJOHO Architecture (LEE Jeonghoon) (photo: Hong Cheolki)

22 조호건축, 〈시간의 정원〉, 2022, 렌더링 이미지. ⓒ조호건축(이정훈)
JOHO Architecture, *Garden in Time*, 2022, rendered image.
ⓒJOHO Architecture (LEE Jeonghoon)

시간의 정원
Garden in Time

조호건축, 〈시간의 정원〉, 2022, 렌더링 이미지. ⓒ조호건축(이정훈)
JOHO Architecture, *Garden in Time*, 2022, rendered image.
ⓒJOHO Architecture (LEE Jeonghoon)

83

이정훈(조호건축)

2009년 2월 설립된 조호건축은 건축가 이정훈의 새로운 브랜드명으로 한문으로 造好(지을 조, 좋아할 호)의 의미를 가진다. 건축을 인문학적 기반 위에서 해석하고 이를 바탕으로 현대 도시의 새로운 정체성과 담론을 생성해 내는 것을 이념으로 설립되었다. 또한, 분업화된 시스템 속에서의 개별적 건축가가 아닌 건축 산업을 리드하는 종합적인(total) 디자인을 추구한다. 조호건축은 재료(material)를 일종의 기하 측정(geo_metry)의 단위로 설정하고 이들의 군집과 가감을 통하여 디자인을 발전시키고 있다. 이러한 재료 측정(material_metry)은 재료가 지닌 의미를 대지의 맥락(context)에서 재해석하는 것을 의미하며, 궁극적으로 건축 공간을 인문학적 토대 위에 재구축함을 목표로 한다.

조호건축의 대표 건축가 이정훈은 건축과 철학을 공부하고 프랑스 낭시건축대학교, 파리라빌레트건축대학교에서 건축재료학 석사 학위 및 프랑스건축사를 취득하였다. 이후 세계적인 건축 사무소인 시게루 반(Shigeru Ban), 자하 하디드(Zaha Hadid) 사무소에서 근무하였고, 2009년 서울에 조호건축을 개소하였다. 2010년 젊은건축가상, 2013년 미국 건축잡지 『아키텍쳐럴 레코드』에서 선정하는 디자인 뱅가드(세계 건축을 이끌 차세대 10인의 건축가상), 독일 프리츠 회거 건축상, 미국 시카고 아테네움 건축상, 독일 ICONIC 건축상, 한국건축가협회상, 한국건축문화대상, 김종성 건축상, 문화체육관광부 오늘의 젊은 예술가상 등 다수의 국내외 건축상을 수상하였다. 서울시 공공건축가, 충청남도 수석공공건축가로 활동한 바 있으며, 대표작으로는 헤르마 주차빌딩(2010), 곡선이 있는 집(2012), 플랫폼 엘 컨템포러리 아트센터(2016), 클럽나인브릿지 파고라(2017), 선유재(2019), 울산 KTX 주차빌딩(2019) 등이 있다.

Lee Jeonghoon (JOHO Architecture)

Founded in February 2009, JOHO Architecture is a new brand launched by architect Lee Jeonghoon, the name of which combines two Chinese characters, *jo* (造, meaning "to build") and *ho* (好, meaning "to like"). JOHO Architecture was founded upon the goal of understanding architecture from a humanities point of view and imbuing the contemporary city with a new identity and discourse. JOHO Architecture pursues "total design" as a leader, not of individual architects scattered across the divided work system, but of the entire architecture industry. The studio posits materials as units of "geo_metry" and develops designs by assembling, adding, or subtracting the units. This kind of "material_metry" reinterprets the meaning of materials within the context of land and ultimately aims to reconstruct architectural spaces on the foundation of humanities.

JOHO Architecture's principal architect Lee Jeonghoon majored in architecture and philosophy and earned a master's degree in architectural materials from Nancy School of Architecture and a DPLG degree from Paris La Villette School of Architecture. He worked at renowned international architecture firms such as Shigeru Ban Architects and Zaha Hadid Architects before founding JOHO Architecture in Seoul in 2009. He received a number of awards in and outside of Korea including the Young Architects Award (Korea, 2010); the Design Vanguard Award presented to 10 next-generation leaders of world architecture by *Architectural Record* (US, 2013); the Fritz Höger Award for Brick Architecture (Germany); the International Architecture Award by the Chicago Athenaeum Museum (US); the ICONIC Award (Germany); the Korean Institute of Architects (KIA) Award (Korea); the Korean Architecture Award (Korea); the Kim Jong Seong Architecture Award (Korea); and Young Artist Award by Ministry of Culture, Sports, and Tourism (Korea). He served as a Seoul Public Architect and a Chungcheongnam-do Chief Architect. His representative works include the Herma Parking Building (2010), the Curving House (2012), Platform_L Contemporary Art Center (2016), Pergola of The Club at NINE BRIDGES (2017), Eaves House (2019), and the Ulsan KTX Parking Complex (2019).

건축
이정훈(조호건축사사무소, 소장)
박채령(조호건축사사무소, PM)

시공
황형주(바른비아이엠스틸, 이사)
박환모(바른비아이엠스틸, 이사)

구조
김형만(허브구조엔지니어링, 소장)
최정명(허브구조엔지니어링, 차장)

조명
정미(이온SLD, 대표)
김세희(이온SLD, 팀장)

가구
HAY

Architecture Design
Lee Jeonghoon (principal, JOHO Architecture)
Park Chae Ryeong (project manager,
JOHO Architecture)

Construction
Hwang Hyeong Joo (director, Barun BIM Steel)
Park Hwan Mo (director, Barun BIM Steel)

Engineering
Kim Hyeong Man
(principal, Hub Structural Engineering)
Choi Jeong Myeong
(deputy senior manager, Hub Structural Engineering)

Lighting
Jeong Mee (president, Eon SLD)
Kim Se Hee (team leader, Eon SLD)

Furniture
HAY

최종후보군
Finalists

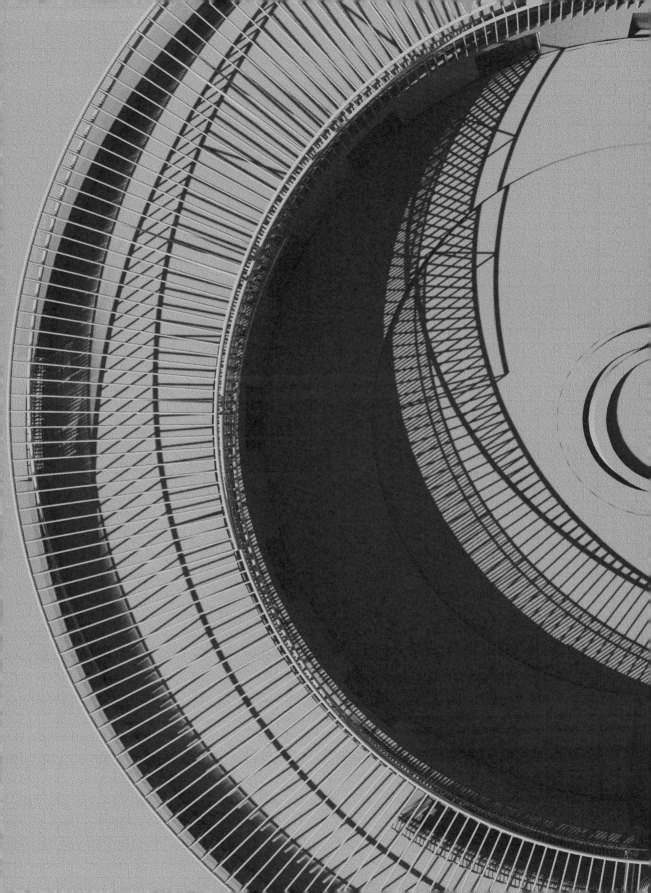

정형의 변형　　　Tweaking Symmetry

정형의 변형

1986년에 개관한 국립현대미술관 과천관 중앙에 자리 잡은 로툰다는 건축가 김태수의 설계 의도대로 중요한 역할을 담당한다.

> (…) 〈국립현대미술관〉의 램프는 커넥팅 코리도(connecting corridor), 층층이 연결해 주는 메인 코어와 동선의 역할을 합니다.[1]

본 제안은 프로젝트 대상지인 3층 옥상정원을 벗어나 과천관의 구심점인 로툰다와 주 출입구까지 영역을 확장하였다. 로툰다를 중심으로 미술관 내부 축이 자리 잡고, 좌측과 우측에 층별로 전시실이 배치된다. 전시실 간 수직 이동이 가능한 곳도 있지만, 대부분 로툰다의 원형 경사로를 이용하여 관람객의 층별 이동을 유도한다. 옥상정원은 원형 경사로의 최상단에서 외부로 나가 다다르게 된다. 반지름 19m, 폭 6.5m, 바닥 면적 800m² 원호가 만들어내는 도넛 형태의 옥상정원은 광활한 자연을 맞이하는 반듯한 공간이다. 바깥쪽으로는 청계산, 관악산, 매봉산 능선, 호수(과천 저수지), 서울랜드 등 파노라믹 원경이 펼쳐지고, 안쪽으로는 2층 원형정원이 내려다보인다. 관람객은 360도 선택적으로 열려있는 공간에 매료되지만, 한편으로는 방향성과 목적성을 잃은 채 옥상정원에서의 기억이 짧을 수도 있다.

원형 로툰다에서 파생되는 중심성, 대칭성과 축, 그리고 주요 전시 공간도 원형, 사각형 등 순수한 기하학적 구조(geometry)로 구성된다. 이러한 예측 가능한 정형에 변형을 가하여 안정감 속에 새로운 활력을 불어넣고자 한다.

정형인 듯하지만 1개의 변곡점에서 2개의 원호가 합쳐져 생긴 궤도를 갖는 경사로를 제안하여, 옥상정원에서 더욱 다양한 행위와 풍경을 의도하고자 한다. 뿐만 아니라, 활용도가 적었던 2층 원형정원과 3층 옥상정원을 이어주는 외부 계단을 더욱 활성화하여 로툰다의 원형 경사로와 더불어 미술관에서의 이동 경험을 더욱 풍요롭게 해줄 장치로 기능하고자 한다. 경사로 구조물은

Tweaking Symmetry

The rotunda located in the center of the National Museum of Modern and Contemporary Art, Gwacheon (MMCA Gwacheon), opened in 1986, plays an important role in the museum as intended by its architect Kim Tai Soo.

> (…) the one [ramp] at the *National Museum of Modern and Contemporary Art* functions as a main core and path that connect different stories of the building as a connecting corridor.[1]

The *Tweaking Symmetry* proposal expands the scope of the MMCA Gwacheon Project site beyond the Rooftop on the third floor, the original site, to the rotunda and main entrance at the center of the museum. The rotunda holds the interior axis of the museum, and galleries are located to its right and left on each floor. Although some galleries are connected vertically by stairs, most of them are intended to be accessible by the circular ramp of the rotunda. The Rooftop is connected to the top of the circular ramp through an open-air space. With a 19-meter radius, the donut-shaped Rooftop is 6.5 meters in width for a floor area of 800 square meters. A symmetrical space open to the vastness of nature, it provides a panoramic view of the ridges of Cheonggyesan Mountain, Gwanaksan Mountain, and Maebongsan Mountain, as well as Gwacheon Reservoir and Seoulland. The Circular Garden on the second floor is also visible from the opening in the middle of the Rooftop. This 360-degree open space can fascinate visitors, but has the potential to be not that memorable due to its lack of direction and purpose.

The museum's centrality, symmetry, and axis, derived from the rotunda, as well as the design of its major exhibition spaces are all based on pure geometry, such as circles and quadrangles. This proposal aims to tweak these predictable symmetric shapes to revitalize the space in

김이홍(김이홍 아키텍츠)

대형 오브제로, 옥상정원에서는 압도적인 조형감을, 원경에서는 미술관 상부에 호기심을 자아낼 만한 새로움을 선사할 것이다.

의도된 기하학적 질서로 설계된 국립현대미술관 과천관에 〈정형의 변형〉이 작지만 강렬한 에너지를 발산하여 미술관 전체에 파급력을 끼치길 기대한다.

Kim Leehong (Leehong Kim Architects)

harmony with its stability.

This proposal outlines a ramp whose track is formed by the junction of two circular arcs with a single inflection point, creating a space in the Rooftop for more diverse actions and landscapes. Furthermore, the underused outside stairs that connect the Circular Garden on the second floor and the Rooftop on the third are intended to serve as a device to enhance the experience of moving through the museum along with the circular ramp of the rotunda. The ramp structure in the Rooftop is a large object that will arouse a sense of being overwhelmed by its hugeness, and at the same time, when seen from afar, ignite curiosity about the top of the building with its novelty.

With its small but intense energy, *Tweaking Symmetry* is expected to have far-reaching implications for the entire space of MMCA Gwacheon, a museum designed with intentions for geometric order.

1 국립현대미술관, 『한국현대미술작가시리즈 김태수』, 과천관 30년 특별전 도록(과천: 국립현대미술관, 2016), 22.

1 MMCA, *Kim Tai Soo Retrospective: Working in Two Worlds*, exh. cat. (Gwacheon: MMCA, 2016), 30.

약 70m

김이홍 아키텍츠, 〈정형의 변형〉, 2022, 도면도. ⓒ김이홍 아키텍츠
Leehong Kim Architects, *Tweaking Symmetry*, 2022, plan drawings. ⓒLeehong Kim Architects

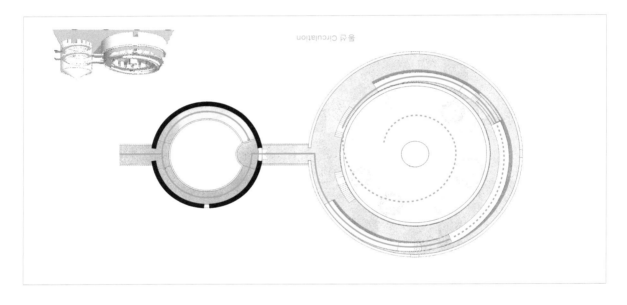

동선 Circulation

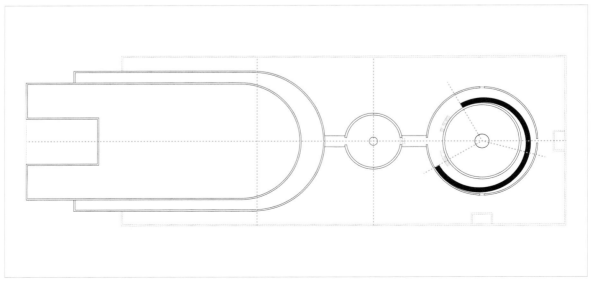

김이홍 아키텍츠, 〈장항의 판본〉, 2022, 모형 사진. ⓒ김이홍 아키텍츠 (사진: 홍철기)
Leehong Kim Architects, *Tweaking Symmetry*, 2022, model photos. ⓒLeehong Kim Architects
(photo: Hong Cheolki)

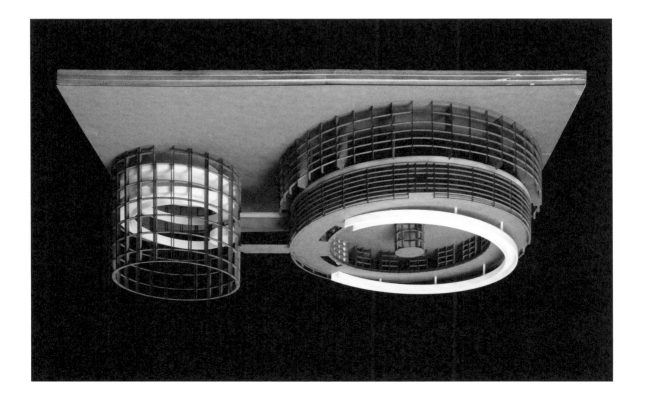

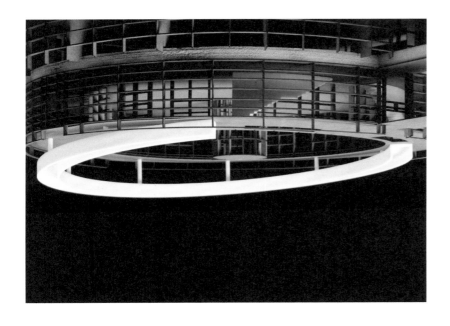

김이홍 아키텍츠, 〈정형의 변형〉, 2022, 렌더링 이미지. ⓒ김이홍 아키텍츠
Leehong Kim Architects, *Tweaking Symmetry*, 2022, rendered images. ⓒLeehong Kim Architects

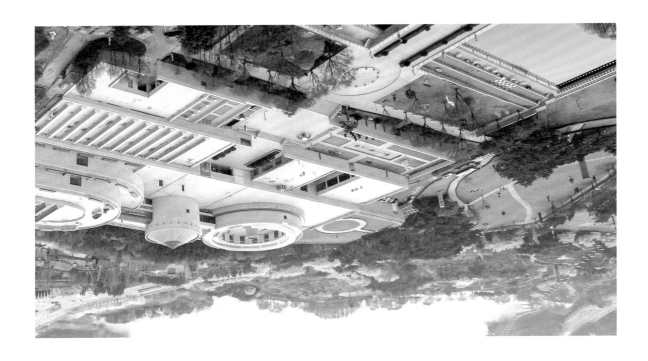

김이홍 아키텍츠, 〈장평리 별장〉, 2022, 렌더링 이미지. ⓒ김이홍 아키텍츠
Leehong Kim Architects, Tweaking Symmetry, 2022, rendered images. ⓒLeehong Kim Architects

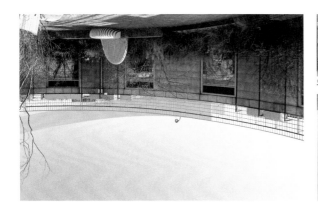

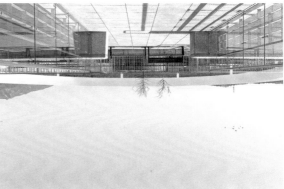

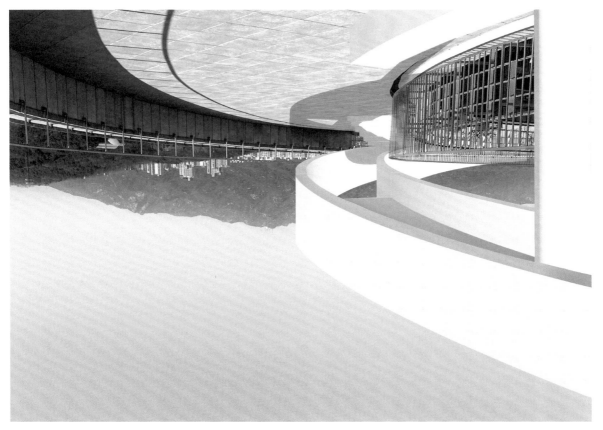

김이홍(김이홍 아키텍츠)

김이홍 아키텍츠는 2014년 뉴욕에서 Leehong Kim Architects를 개소하였으며, 2016년에는 서울로 사무실을 확장하여 프로젝트를 진행하고 있다.

건축, 도시재생, 인테리어, 공공예술, 제품디자인 등 인간의 삶과 관련된 다양한 스케일의 이슈를 탐구하며 아이디어를 구체화하고 실제로 구현하는 작업에 관심을 갖고 있다. 혼자만의 작업뿐 아니라, 분야별 협업자들과의 작업과 전시 디렉팅 등 관계 속에서 새로움을 발견하는 작업을 꾸준히 하고자 한다.

김이홍은 건축가이자 홍익대학교 조교수로 재직 중이다. 연세대학교 건축공학과와 하버드대학교 건축대학원을 졸업하였으며, 게리 파트너스(Gehry Partners), 삼우종합건축사사무소, 스티븐 홀 아키텍츠(Steven Holl Architects)에서 실무를 익혔다. 김이홍 아키텍츠를 개소하여 건축, 인테리어, 공공예술, 전시 디렉팅 등 다양한 스케일의 프로젝트를 진행 중이다. 2009 광주디자인비엔날레, 아모레퍼시픽미술관의 《APMAP 2016 yongsan-make link》 등에 전시 참여 작가로, 《2019 설화문화전》에 디렉터로 참여하였으며, 2018년 젊은건축가상을 수상하였다. 미국 건축사와 미국 친환경 인정 기술사(LEED AP)이며, 현재 서울시 공공건축가로 활동하고 있다.

건축
김이홍(김이홍 아키텍츠, 소장;
홍익대학교 건축도시대학원, 조교수)

구조자문
동근욱((주)은구조기술사사무소, 소장)

Kim Leehong (Leehong Kim Architects)

Leehong Kim Architects was founded in New York in 2014. With its second office set up in Seoul in 2016, the firm manages diverse projects that explore issues of various scales pertaining to human life from architecture, urban regeneration, and interior design, to public art, and product design, developing and materializing ideas into reality. Beyond individual projects, the firm constantly works with artists in different fields through exhibition directing and other projects to discover something new from the relationships.

Architect Kim Leehong also serves as an assistant professor at Hongik University. He graduated from the Department of Architectural Engineering at Yonsei University and the Harvard Graduate School of Design, and acquired experiences working for Gehry Partners, Samoo Architects & Engineers, and Steven Holl Architects. Since the founding of Leehong Kim Architects, he has been working on projects of diverse scales from architecture to interior design, public art, and exhibition directing. He participated in the 2009 Gwangju Design Biennale and *APMAP 2016 yongsan-make link* at the Amorepacific Museum of Art as an artist, directed the *2019 Sulwha Cultural Exhibition*, and won the Korea Young Architect Award in 2018. He is a registered architect and a LEED Accredited Professional (AP) in the US and is currently serving as a Seoul Public Architect.

Architecture Design
Kim Leehong (principal, Leehong Kim Architects; assistant professor, Graduate School of Architecture & Urban Design at Hongik University)

Engineering Consulting
Dong Keun Wook
(principal, Eun Structural Engineering)

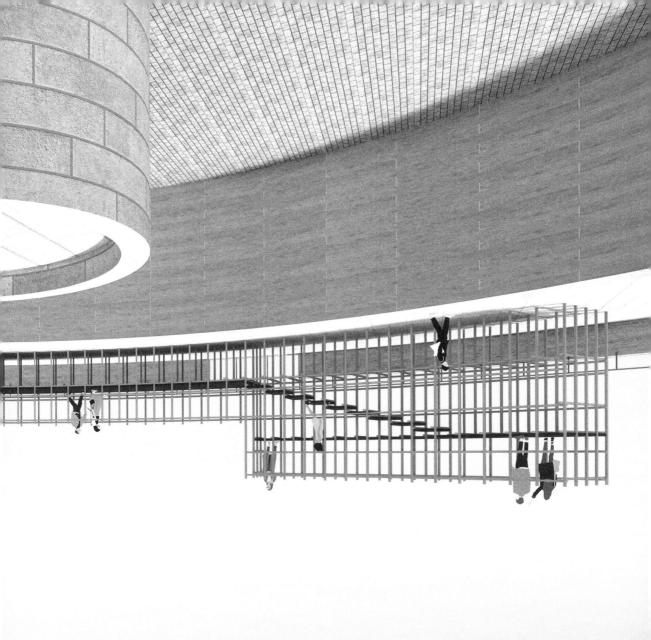

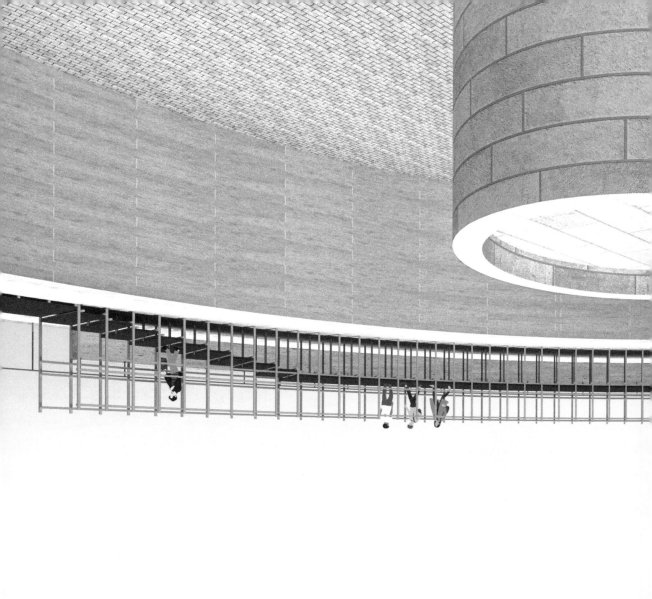

(건축공방)

박수정, 심희준

Park Su-Jeong,
Sim Hee-Jun
(ArchiWorkshop)

과천오름

국립현대미술관 과천관으로 가는 길은 특별한
분위기가 있다. 구불구불 산길을 따라 도착하는
여정은 도심 미술관과 다른 무언가가 있다. 미술관
도입인 야외조각공원에 도착하면 시간 변화와 함께한
현대조각품들이 자리한다. 견고히 지어진 건축물
중앙에는 백남준 작가의 〈다다익선〉이 전시되어 있다.
작품을 보면서 올라가는 램프 길 끝은 미술관 가장
높은 곳에 있는 옥상과 연결된다. 여러 차례 미술관을
왔지만 이런 곳이 있었구나 하는 생각이 든 것은 우리가
이곳에 올라올 특별한 이유가 없었던 탓이다. 산과
호수로 둘러싸인 이 공간은 원형의 건축물 모습을 따라
파노라마로 자연 풍광을 만나게 한다. 어떤 장소가 되면
좋을까. 우리는 이 공간이 현대미술관의 옥상이라는
점에서 좋은 풍경을 보는 그 이상의 파빌리온을 고민하고
있었다. 현대미술, 동시대미술이라고 하는 것이 미술의
한계가 사라지고 모든 것이 미술이 될 수 있다는 개념을
시작으로 우리의 생각이 이어졌다.

네덜란드에는 동측에 해수면보다 높은 대지에 위치한
국립 공원이 있다. 구릉이 거의 없는 이곳은 철저하게
야생 동물과 식생을 보존한다. 주차장 공간은 공원
밖에서 제한되고, 방문객들은 하얀색 자전거를 타고
국립 공원의 다양한 장소를 방문한다. 여러 장소 중에
크뢸러뮐러미술관이 있는데, 이곳 야외 조각 공원에
설치된 작업들 중에 직접 작품에 들어가서 눕거나 앉을
수 있는 롭 스위어(Rob Sweere)의 〈허브〉(The Herb)와
설치작업에 들어갈 수 있는 장 뒤뷔페(Jean Dubuffet)의
〈에나멜 정원〉(Jardin d'émail)은 방문자와 작품 간에
새로운 관점을 제시해 준다.

우리는 다가가기 힘들고, 만질 수 없는 작품이 아니라
파빌리온 자체가 이용되고 또 파빌리온을 통한 사람들의
행위가 미술의 한 부분이자 완성이 될 수 있다고
생각했다. 〈과천오름〉은 과천관에 오면서 경험하는
오르는 여정의 마지막 단계이자 다시 현실로 돌아가기
위해 내려가는 시작이기도 하다. 우리는 사람들이 이
장소에서 자연을 바라보는 다양한 높이가 있는 장소를

Gwacheon OREUM

The winding, mountainous journey to MMCA
Gwacheon has a peculiar vibe that distinguishes
the museum from those in the city. The Outdoor
Sculpture Park at the museum entryway holds
contemporary sculptures that have witnessed
history. At the core of the sturdy museum building
is Paik Nam June's *The More, The Better*, and the
spiral ramp around the monumental work leads
to the highest level of the museum-the Rooftop.
Each of us at ArchiWorkshop has been to the
museum many times, but we were surprised to
discover that the museum had such a Rooftop,
probably because we never felt a particular need
to go up there. Surrounded by the mountains and
the lake, the Rooftop takes after the structure of
the circular building, offering a panoramic view
of the natural scenery. What could we do with
this space? We thought of a pavilion, a place
that offers more than a scenic view, considering
that the Rooftop is part of a contemporary art
museum. Thoughts on contemporary art—how art
is boundless and can be anything—were where
our idea departed.

On the eastern border of the Netherlands, there
is a national park located above sea level. With
almost no hills, the park is dedicated to the
conservation of wildlife and vegetation. The
parking areas are limited to the outskirts of
the park, and visitors can explore its different
sites on white bicycles. Among the various sites
is the Kröller Müller Museum and its outdoor
sculpture garden, among whose sculptures and
installations are Rob Sweere's *The Herb* and Jean
Dubuffet's *Jardin d'émail*. These works invite
visitors to enter, sit on, or lie on them, proposing
a new relationship between an artwork and its
spectators.

Instead of something guarded and
unapproachable, we came up with the idea of a
pavilion as an artwork that becomes complete
through people's interaction with and utilization

제안한다. 때로는 앉거나 누울 수 있는 평상같이, 가볍게 걸터앉는 의자같이 그리고 가장 높은 곳에서 바라보는 전망대같이, 〈과천오름〉은 사람들의 움직임과 시선을 담는다. 안전과 제한을 위한 핸드레일 너머로 보이는 풍경을 찾아서 올라가도록 움직임을 유도하는 작업이다. 이렇게, 규정되지 않지만 자유롭게 이루어지는, 즉 이루어질 움직임들이 〈과천오름〉이 된다. 움직임이 미술이 된다. 미술과 함께하는 것은 이곳에서 매우 일상적인 일이며 경험이다.

우리는 〈과천오름〉이 옥상의 매스를 압도하지 않고 오히려 하늘 풍경에 스며드는 것을 상상한다. 얇은 프레임들이 모여 장소를 만들지만, 마치 새의 둥지처럼, 물건을 거르는 체처럼 성글게 엮인 구조들이 옥상에 가볍게 설치된다. 푸른색이 입혀진 프레임들은 옥상에서 가장 많은 면적을 가진 하늘의 색이다. 처음 미술관 야외조각공원에 들어온 사람들이 옥상에서 움직이는 사람들을 보며 장소를 인지하고, 〈과천오름〉의 여정을 함께하기를 기대한다.

of it. This pavilion, *Gwacheon OREUM*, can mark both the end of the journey up through the museum and the beginning of the journey back down, or back to reality. We propose this pavilion as a place that embodies the different heights from which people can view the surrounding landscape. Serving as a flat bench to lie on, a chair to sit on, or an observatory from which to look down, *Gwacheon OREUM* will capture people's movements and perspectives. The work will entail guiding visitors up to the pavilion, where they will encounter the scenic view, from behind a railing that ensures their safety. As such, the unpredictable and free movements and gestures made or that are bound to be made or that are bound to be made by the viewers will become *Gwacheon OREUM* in and of themselves. Movements becoming art-this kind of artistic happening or experience must feel natural and commonplace at a museum such as MMCA Gwacheon.

We envision *Gwacheon OREUM* not as a mass that imposes itself on the Rooftop but rather as a structure that blends into the skyscape. The structure will have a thin, sparsely assembled framework like a bird's nest or a sieve to exude a faint presence on the Rooftop. The framework will be painted blue, the color of the sky that dominates the overall Rooftop. We expect that visitors who first enter the museum through the Outdoor Sculpture Park will notice the structure through the movements of the people on the Rooftop and join the journey to *Gwacheon OREUM*.

건축공방, 〈과천오름〉, 2022, 모형 사진. ⓒ건축공방 (사진: 홍철기)
ArchiWorkshop, *Gwacheon OREUM*, 2022, model photos. ⓒArchiWorkshop (photo: Hong Cheolki)

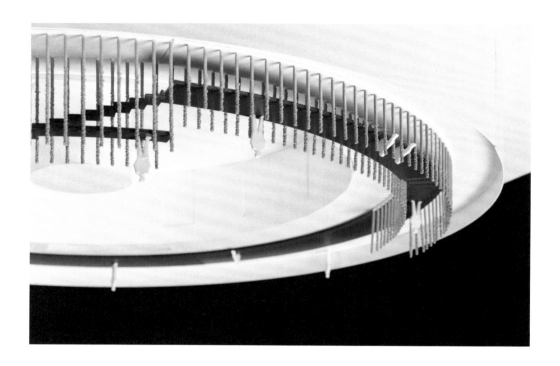

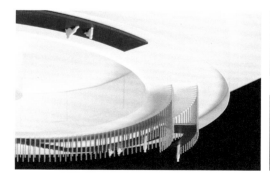

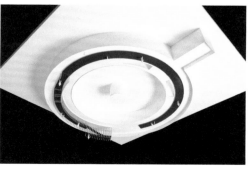

건축공방, 〈과천오름〉, 2022, 렌더링 이미지. ⓒ건축공방
ArchiWorkshop, *Gwacheon OREUM*, 2022, rendered images. ⓒArchiWorkshop

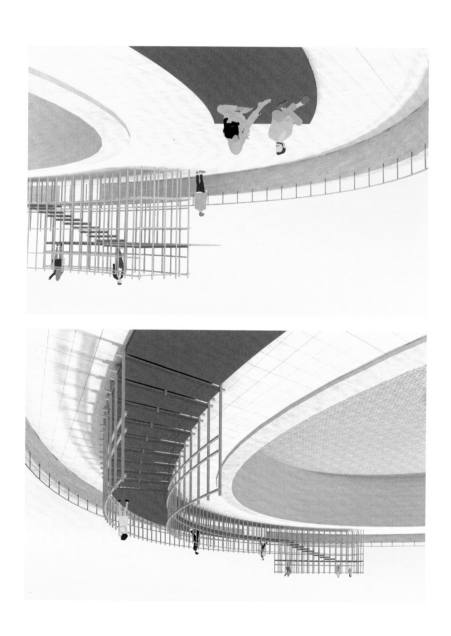

건축공방, 〈과천오름〉, 2022, 렌더링 이미지. ⓒ건축공방
ArchiWorkshop, *Gwacheon OREUM*, 2022, rendered image. ⓒArchiWorkshop

박수정, 심희준(건축공방)

건축공방은 일상의 건축을 생각하고, 짓고, 누리고, 공유하는 건축가들이다. 2019년 젊은건축가상을 수상하였으며 2021 서울도시건축비엔날레 'Global Studios'의 큐레이터를 수행하였다. '건축공방'이라는 이름은 두 가지 의미를 가지고 있다. 하나는 '건축가의 작업실(Workshop)'이라는 의미이고, 다른 하나는 '서로 의견을 교류하는 토론(Discussion)'이라는 의미이다. 건축은 결과적으로 보면 시각적인 작업이지만, 태생은 철학적이고 합리적인 사고를 동반하는 작업이다. 그런 이유로 우리는 스케치만큼이나 토론과 대화를 중요시하면서 작업을 진행하는데, 이런 방식은 더 영향력 있는 작업과 결과를 가능하게 한다. 건축공방이 말하는 일상의 건축은 높은 수준의 건축을, 즉 건강한 환경의 건축과, 더 많은 사람들이 이를 누릴 수 있는 확대된 건축 문화를 의미한다.

건축공방 대표 박수정은 광운대학교 건축공학과를 졸업하고, 네덜란드 델프트공과대학교에서 에라스무스 교환 학생으로 수학하였으며, 독일 슈투트가르트대학교를 졸업(디플로마)하였다. 이후, 유럽의 건축 설계 사무소인 베니쉬 건축사무소(Behnisch Architekten), 메카누(Mecanoo), 오이코스(Oikos)에서 실무 경험을 쌓았다. 현재 광운대학교 건축학과 겸임교수와 새건축사협회 정책위원, 서울시 공공건축가, 동작구 경관위원, 안성시 공공건축 심의위원으로 위촉되어 활동하고 있다.

건축공방 대표 심희준은 스위스 취리히연방공과대학교에서 교환 학생으로 수학하고, 독일 슈투트가르트대학교를 졸업(디플로마)하였다. 이후, 유럽의 건축 설계 사무소인 렌조 피아노 건축사무소(Renzo Piano Building Workshop), 헤르조그 앤 드뫼론 건축사무소(Herzog & de Meuron), 라쉬 앤 브라다취 건축사무소(Rasch & Bradatsh)에서 실무 경험을 쌓았고, 렌조 피아노가 설계한 KT 본사 청진동 사옥의 디자인 감리 컨설팅을 맡았다. SH 청신호 건축가로 활동한 바 있으며, 현재 서울시립대학교 건축학과 겸임교수와 중앙대학교 대학원 디자인학과 겸임교수, 새건축사협회 정책위원, 건축명장 운영위원회로 활동하고 있다.

Park Su-Jeong & Sim Hee-Jun (ArchiWorkshop)

ArchiWorkshop is an architectural studio dedicated to the ideation, creation, appreciation, and sharing of "everyday architecture." The duo won the Korea Young Architect Award in 2019 and curated the "Global Studios" at the 2021 Seoul Biennale of Architecture and Urbanism. The word *gongbang* in the studio's Korean name "Geonchuk Gongbang" has two meanings: "workshop," as in an architect's workplace, and "discussion," as to exchange opinions. While architecture is ultimately a visual process, it inherently entails philosophical and rational thinking. For that reason, the duo places as much emphasis on discussion and conversation as sketching in their work process, which allows them to produce more influential projects and outcomes. ArchiWorkshop's definition of "everyday architecture" is an expanded form of an architectural culture in which quality architecture surrounded by a healthy environment is enjoyed by more people.

Park Su-Jeong, founder and principal architect of ArchiWorkshop, graduated from the Department of Architectural Engineering at Kwangwoon University. She participated in Erasmus exchange student program at Delft University of Technology in the Netherlands and graduated from the University of Stuttgart in Germany (Diploma). She worked at several European architectural firms including Behnisch Architekten, Mecanoo, and Oikos and currently teaches architecture and design as an adjunct professor at Kwangwoon University. She is also a Seoul Public Architect; a committee member at the Korea Architects Institute and the Dongjak-gu Urban Planning Project; and the architecture commissioner of Anseong City.

Sim Hee-Jun, founder and principal architect of ArchiWorkshop, studied at ETH Zürich as an exchange student and graduated from the University of Stuttgart in Germany (Diploma). He worked at a broad range of European architecture firms such as Renzo Piano Building Workshop, Herzog & de Meuron, and Rasch & Bradatsh and served as a design and supervision consultant at KT Headquarters in Cheongjin-dong designed by Renzo Piano. He served as an advisor for the Green Light Project at the Seoul Housing & Communities Corporation. He currently teaches architecture and design as an adjunct professor at the University of Seoul and Chung-Ang University, while also serving as a committee member at the Korea Architects Institute and Master Builder.

건축가
박수정, 심희준(건축공방)

디자인
김승환, 이영목

구조자문
진구조

사진
건축공방

Architects
Park Su-Jeong, Sim Hee-Jun (ArchiWorkshop)

Design
Kim Seung-Hwan, Lee Young-Mok

Engineering Consulting
Jin Structure

Photograph
ArchiWorkshop

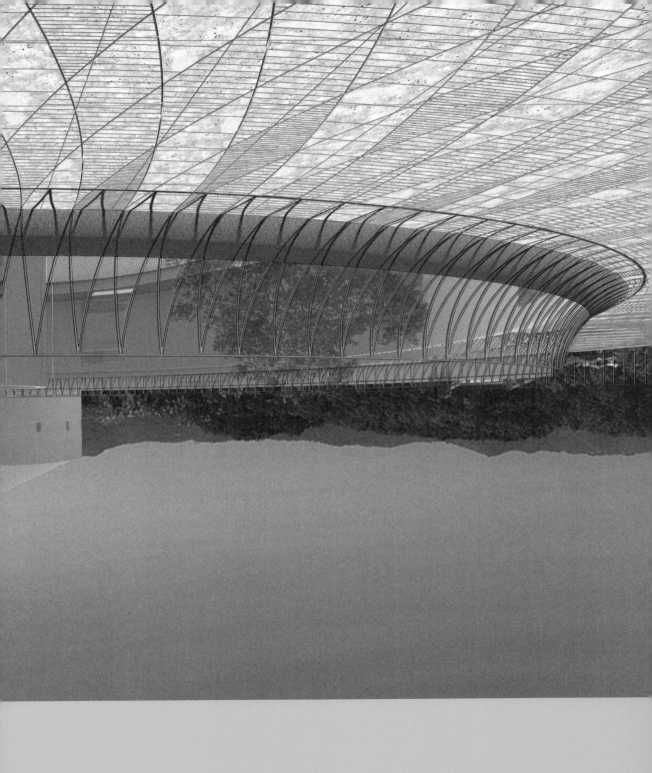

Stone Resurrection

돌의 부활

박희찬(스튜디오 히치)

**Park Heechan
(Studio Heech)**

돌의 부활

Stone Resurrection

이 프로젝트는 1986년 김태수가 그리고자 했던 돌 이야기에 주목한다. 단순한 기하학적 볼륨과, 국산 화강석으로 우리 강산의 색과 질감을 표현한 미술관의 돌 이야기. 미술관이 지어졌을 당시보다는, 지속 가능성(sustainability)과 돌이라는 소재에 대한 거대한 인식 변화를 맞이한 지금 우리 시대에 오히려 더 큰 울림으로 다가온다.

이 프로젝트는 21세기 디지털 기술을 활용해 그가 그렸던 돌 이야기가 더 온전하게 경험되는 것을 목적으로 한다. 김태수의 원리와 달리 전혀 다르게 변형된 옥상정원 공간을 온전하게 완성하기 위한 지속 가능한 재생 방안을 제안한다. 또한 설치작품이 야기하는 폐기물, 쓰레기에 대한 보다 근본적인 물음에 답하고자 한다.

미술관 경험

비워진 원형 옥상정원은 김태수가 과천관을 통해 그리고자 했던 미술관 경험을 완성하는 공간이다. 미술관 전시 동선을 지배하는 나선 램프를 따라가다 보면, 방문객들은 가장 꼭대기의 비워진 원형 옥상정원으로 인도된다. 한 바퀴를 크게 돌면서 펼쳐지는 청계산 풍경을 파노라마로 감상하게 된다. 현재 원형 옥상정원은 600mm × 600mm의 직교하는 대리석 패턴으로 마감되어 있다. 안타깝게도 이는 원형의 기하학에 순응하는 패턴으로 그려진 김태수의 1986년 설계 도면과는 거리가 있다. 또한 강화된 안전 법규에 대응하고자 기존 난간 앞쪽에 덧붙인 스테인리스 난간은 사려 깊게 계획되지 않았고, 우레탄 방수 페인트가 그대로 노출된 트렌치 등의 부조화 요소들이 옥상정원을 산만하게 만들어 공간과 풍경에 집중할 수 없게 한다.

This project pays attention to the story architect Kim Tai Soo sought to tell through stone in 1986; the story of a museum constructed out of pure geometric volume and domestic granite to embody the colors and textures of Korea's natural elements. This story has deeper resonance in our time, as the perceptions of sustainability and stone as a material have greatly changed since the museum was built.

This project aims to offer a full experience of the story using 21st-century digital technology, proposing a sustainable regeneration of the Rooftop, which ended up significantly altered from Kim's plan, to fully restore it into the space initially envisioned by the architect. It also proposes a solution to the more fundamental issue of waste and garbage that installation projects tend to generate.

Museum Experience

The empty circular Rooftop becomes a space that completes the experience of MMCA Gwacheon as intended by Kim. Walking up the spiral ramp, which directs the flow of traffic through the museum's exhibitions, visitors are guided up to the empty circular Rooftop, where they are inclined to walk in a circle, appreciating the panoramic view of Cheonggyesan Mountain. The Rooftop is currently paved with 600-square-millimeter marble tiles laid in an orthogonal pattern, which, unfortunately, does not correspond to Kim's 1986 blueprint specifying a pattern compliant to the rules of circle geometry. Also, the stainless steel railing added on in response to the reinforced security regulations weren't thoughtfully planned, and incongruous elements such as the trench with an exposed urethane waterproofing coating disrupt the overall look of the Rooftop and distract viewers from the experience of the space and scenery.

박희찬(스튜디오 히치)

돌의 부활

1986년의 김태수는 상상도 할 수 없었던 돌의 가공과 표현이 21세기 디지털 패브리케이션(digital fabrication) 기술[1]에 의해 가능해졌다. 샌드 블라스팅(sand blasting),[2] 씨엔씨(CNC)[3] 등 기술을 활용해 기존 600mm x 600mm 크기의 대리석과 페데스탈 시스템(pedestal system)[4]을 그대로 유지한 채로 새로운 원형 패턴을 삽입한다. 파라메트릭 디자인 도구(parametric design tool)[5]를 통해 창조된 새로운 원형 패턴을 기존 대리석 위에 3mm 깊이로 각인한다. 1,080여 개의 기존 대리석에 번호를 매긴 후 샌드 블라스팅 공장으로 옮겨 패턴을 각인하고, 다시 옥상정원으로 옮겨 원래 있던 자리에 올린다. 원형 패턴은 확장되어 트렌치와 새로운 난간으로 이어진다. 하나의 거대한 원형 패턴이 3차원적으로 삽입되어 기존 옥상정원은 김태수의 원리에 따르면서도 완전히 새로운 공간으로 탈바꿈한다.

1 씨엔씨(CNC), 레이저 컷팅(laser cutting), 워터젯(waterjet), 3D 프린팅(3D printing)등 디지털 기술을 활용한 제조 기술.

2 모래를 분사하여 표면을 깎거나 연마하는 기술.

3 Computer numerical control의 약자로, 미리 프로그램된 소프트웨어를 활용해 정교한 가공을 가능하게 하는 디지털 생산 방식.

4 내외부 바닥재를 시공할 때 시멘트 몰탈 대신 받침대를 활용하는 시스템.

5 컴퓨터를 활용하여 컴퓨터 로직을 토대로 수많은 형상과 복잡한 패턴들을 파생시킬 수 있는 디지털 디자인 방법.

Park Heechan (Studio Heech)

Stone Resurrection

Thanks to digital fabrication technology,[1] methods of stone processing and manipulation that Kim would never have thought possible in 1986 are available today. Using techniques such as sandblasting[2] and CNC,[3] a new circular pattern will be engraved onto the existing marble floor without destroying the existing 600-square-millimeter marble tiles and the pedestal system.[4] This new circular pattern, created through a parametric design tool,[5] will be engraved to a depth of three millimeters into the 1,080 tiles currently set into the Rooftop floor. These tiles will be numbered, transported to a sandblasting factory for pattern engraving, then transported back to their original spots in the Rooftop. With the circular pattern, which will extend three-dimensionally into the trench and onto the new railing, newly inserted into the space, the Rooftop will be completely regenerated in a way that is faithful to the architect's original plan.

1 A manufacturing technique involving CNC, laser cutting, waterjet and 3D printing.

2 An abrasion technique in which sand is propelled to grind or polish a surface.

3 Acronym for "Computer numerical control," a digital production method in which a pre-programmed software is used for precision machining.

4 A system of interior or exterior flooring in which a pedestal is used instead of cement mortar.

5 A digital design tool that helps generate a wide range of complex structures and patterns based on computer logic.

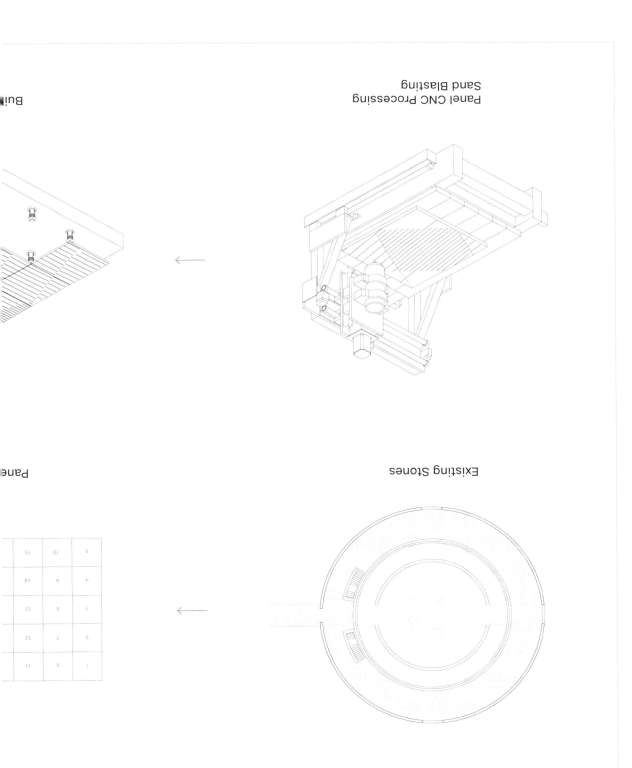

Panel CNC Processing
Sand Blasting

Existing Stones

스튜디오 히치, 〈돌의 부활〉, 2022, 디지털 드로잉(제작 과정), ⓒ스튜디오 히치
Studio Heech, *Stone Resurrection*, 2022, digital drawing (making process), ⓒStudio Heech

ing

Panel Transportation

stal

Proposed Stones

스튜디오 히치, 〈돌의 부활〉, 2022, 모형 사진. ⓒ스튜디오 히치 (사진: 홍철기)
Studio Heech, *Stone Resurrection*, 2022, model photos. ⓒStudio Heech (photo: Hong Cheolki)

스튜디오 히치, 〈돌의 부활〉, 2022, 모형 사진. ⓒ스튜디오 히치
Studio Heech, *Stone Resurrection*, 2022, model photo. ⓒStudio Heech

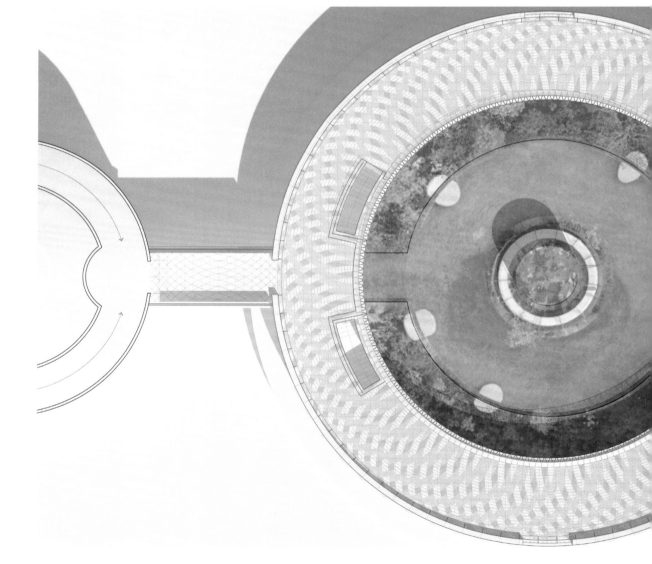

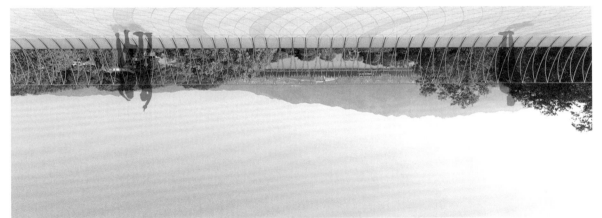

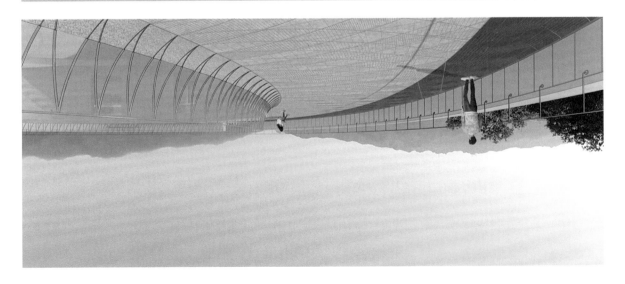

박희찬(스튜디오 히치)

박희찬은 동국대학교와 런던대학교 바틀렛에서 수학하고
M.A.R.U.와 홉킨스 아키텍츠(Hopkins Architects)에서
실무를 쌓았다. 바틀렛 여행 장학금을 수상했고, 런던 로열
아카데미에서 전시를 했다. 영국 건축사로 2018년 서울에서
스튜디오 히치를 설립해 건축, 산업디자인, 패브리케이션,
디지털 인터랙션 등 다양한 분야의 프로젝트를 진행하고 있다.

주요 작품으로는 산양양조장(2020)과 서울어반핀볼머신
(2021)이 있고, 2020년 한국건축가협회상과
대한민국공간문화대상 우수상을 수상하였다. 주요 저서로는
『여행의 기록 알바알토』(시공문화사, 2016)가 있다.

Park Heechan (Studio Heech)

After graduating from Dongguk University and the
Bartlett School of Architecture, University College
London, Park Heechan worked at M.A.R.U. in Seoul
and Hopkins Architects in London. He was selected as
the recipient of the Sir Henry Herbert Bartlett Travel
Scholarship and his work was exhibited in the Royal
Academy of Arts in London. As a qualified architect of
the UK, he founded Studio Heech in Seoul in 2018 and
has worked on various projects across the fields of
architecture, industrial design, fabrication, and digital
interaction.

Park's major projects include Sanyang Brewery (2020)
and Seoul Urban Pinball Machine (2021); and won the
Korean Institute of Architects (KIA) Award and the
excellence award at the Good Place Award in 2020.
and major publications include *Record of Travel, Alvar
Alto* (Spacetime, 2016).

디자인
스튜디오 히치(박희찬, 임재훈, 박언정)

구조자문
김환(Front inc)

Architecture Design
Studio Heech (Park Heechan, Lim Jaehoon,
Park Unjeong)

Engineering Consulting
Kim Hwan (Front inc)

생각의 대기 Atmosphere in Thought

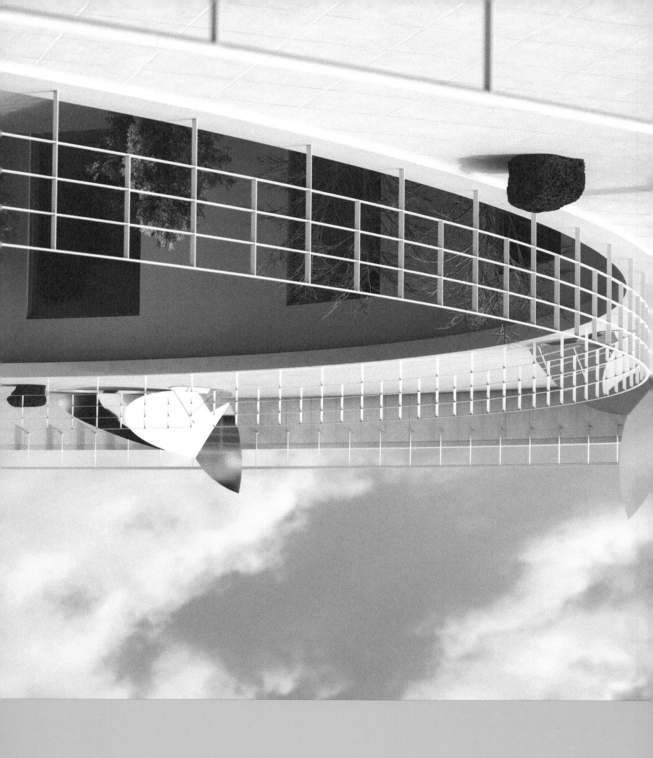

이석우(SWNA)

Lee Sukwoo (SWNA)

생각의 대기

미술관은 영감의 공간이다. 영감을 위해 우리는 미술관을 찾아가고 느끼고 공감한다.

국립현대미술관 과천관의 구조는 저층부터 고층까지 나선형 램프 계단을 통해 오르게 되어있다. 영감의 미술작품들을 가로질러 옥상정원에 들어서면 넓고 확 트인 공간이 나온다. 나는 처음 이 공간에 들어섰을 때 강한 해방감을 느꼈다. 해방감이란 일종의 생각의 해석 또는 생각의 발산과도 같은 의미이다. 특히 영감의 작품들을 만나고 올라가는 옥상정원은 특별한 의미를 지닌다. 생각의 장이 열리며 동시에 닫히는 경험이다. 나는 옥상정원에 들어섰을 때 익숙한 나의 생각과 영감의 생각이 교차하며 낙차를 이루었다. 이런 교집합과 합집합의 사고에서 어떤 식으로든 생각의 전이와 소화가 이루어진다고 생각한다. 그러한 과정을 통해 생각은 사유가 되고 철학의 일부로 남을 것이다.

나는 이러한 과정을 자연스럽게 표현하고 싶었다. 이러한 현상은 바람의 그것과도 닮아있다. 바람이 나의 머리를 스치고 교감하며 느끼고 소화하며 해소되는 일련의 과정을 우리들의 머리와 기억의 형상들로 표현해 보려고 했다. 바람이 끌고 오는 대기와 빛 그리고 자연의 여러 모습을 담을 수 있도록 반사하는 재질의 무언가를 상상하였다. 바람이 이 무언가를 통과하면서 교감하고 다시 반사하며 대기로 날아가는 일종의 소화 행위를 조형으로 풀어내는 과정은 지극히 자연스러웠다. 바람의 상태를 상상하며 다양한 곡선을 자유롭게 흩날리고, 그렇게 해서 나타난 선들의 조합을 종이와 나무를 통해 입체화하여 스케일 모델로 제작하며, 이를 입체화하는 과정에서 즉흥적인 덩어리 형태를 날렸다. 이렇게 만든 7가지의 조각과 이를 둘러싼 돌들을 옥상정원에 자연스럽게 설치하여 보는 이가 함께 앉고 느낄 수 있도록 제작하였다.

Atmosphere in Thought

A museum is a place of inspiration. It is for inspiration that we visit museums, where we experience, sense, and empathize.

MMCA Gwacheon is designed so that visitors can walk up its central spiral ramp from the lower to upper floors. At the end of their walk through the museum's inspirational artworks, visitors enter the wide, open space of the Rooftop. When I first entered this space, I felt an intense sense of liberation, describable as a sort of interpretation, or release of thoughts. Especially after encountering the inspirational artworks, the Rooftop takes on a special meaning, presenting an experience of the mind's gate opening and closing at the same time. Entering the space, I felt a gap open up in my mind as my usual thoughts intersected with newly inspired ones. I believe that it is through such intersections and unions that thoughts are metastasized and digested. Through such processes, thoughts become reason and are established as part of philosophy.

I wanted to visualize this process with an effortless attitude. Thinking that this phenomenon could be likened to that of wind or air, I sought to visualize wind running through my head to be empathized with, digested, and dissipated using images related to the human head and memory. I envisioned a reflective material that could mirror the diverse aspects of the atmosphere, light, and nature that accompany wind. The process of formatively visualizing this act of "digestion"-in which the wind penetrates something, interacts with it, then is reflected back into the air-proceeded effortlessly. Imagining the properties of wind, I laid out various curved lines and assembled them into three-dimensional scale models using paper and wood, spontaneously ridding them of any heavy masses in the process. I then designed the layout of the seven sculptures produced as a result, naturally placing them around the Rooftop with stones so that viewers

이석우(SWNA)

미술관은 결국 생각의 낙차를 만들어내는 일종의
계몽이다. 낙차가 크면 클수록 그 충격은 더해지고
자극은 심해진다. 이러한 경험 공간에서 옥상정원은
올바른 해소 공간이 되어야 한다고 생각한다.

Lee Sukwoo (SWNA)

can sit by the sculptures as they relate to them.

Museums are ultimately institutions of
enlightenment that create gaps in thoughts.
The bigger the gap, the more intense the shock
and stimulation to the viewer. I believe that the
Rooftop at MMCA Gwacheon must become a
space that offers a healthy resolution to such
experiences.

이수우, 〈생각의 대기〉, 2022, 컨셉 이미지. ⓒSWNA
Lee Sukwoo, Atmosphere in Thought, 2022, concept image. ⓒSWNA

이석우, 〈생각의 대기〉, 2022, 모형 사진. ⓒSWNA (사진: 홍철기)
Lee Sukwoo, *Atmosphere in Thought*, 2022, model photos. ⓒSWNA (photo: Hong Cheolki)

이석우, 〈생각의 대기〉, 2022, 모형 사진. ©SWNA (사진: 홍철기)
Lee Sukwoo, *Atmosphere in Thought*, 2022, model photo. ©SWNA (photo: Hong Cheolki)

이석우, 〈생각의 대기〉, 2022, 렌더링 이미지. ©SWNA
Lee Sukwoo, *Atmosphere in Thought*, 2022, rendered image. ©SWNA

이석우, ⟨생각의 대기⟩, 2022, 렌더링 이미지. ⓒSWNA
Lee Sukwoo, *Atmosphere in Thought*, 2022, rendered images. ⓒSWNA

이석우, 〈생각의 대기〉, 2022, 렌더링 이미지. ⓒSWNA
Lee Sukwoo, *Atmosphere in Thought*, 2022, rendered image. ⓒSWNA

이석우(SWNA)

이석우는 홍익대학교에서 산업디자인을 전공하고 삼성전자, 퓨즈프로젝트(Fuseproject)와 티그(Teague)를 거쳐 모토로라 구글(Motorola-Google)에서 글로벌 크리에이티브 리드, 수석 디자이너로 활동 후 2011년 산업디자인 오피스 SWNA를 설립하였다. 2015년 레드 닷 디자인 어워드 콘셉트 디자인 부문 글로벌 탑 10 디자인 스튜디오로 선정되었으며, 2018년 대한민국디자인대상, 2019년 오늘의 젊은 예술가상 디자인 부문을 수상했다. 2021년 삼성디자인멤버십 자문교수, 2021년 독일 iF 디자인 어워드 및 브라운프라이즈 심사위원으로 선정되었다.

Lee Sukwoo (SWNA)

Lee Sukwoo majored in industrial design at Hongik University and worked at Samsung Electronics, Fuseproject, Teague, and as global creative lead and senior designer at Motorola-Google before founding the industrial design studio SWNA in 2011. SWNA was selected as one of the top 10 design studios by the Red Dot Design Award for design concept tracks in 2015 and received the Korea Design Award in 2018 and Today's Young Artist Award in the design category in 2019. In 2021, Lee was selected as an advisory professor for Samsung Design Membership and as a member of the jury for the iF Design Award and BraunPrize 2021 in Germany.

디자인
이석우, 김영빈, 장다정

구조/시공자문
김도현

Design
Lee Sukwoo, Kim Youngbin, Jang Dajeong

Engineering/Construction Consulting
Kim Dohyun

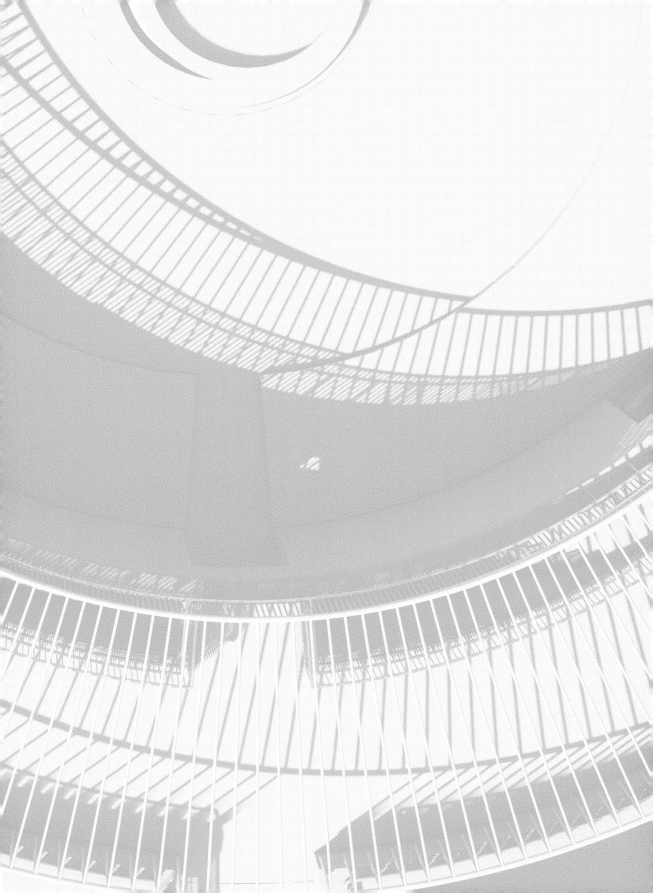

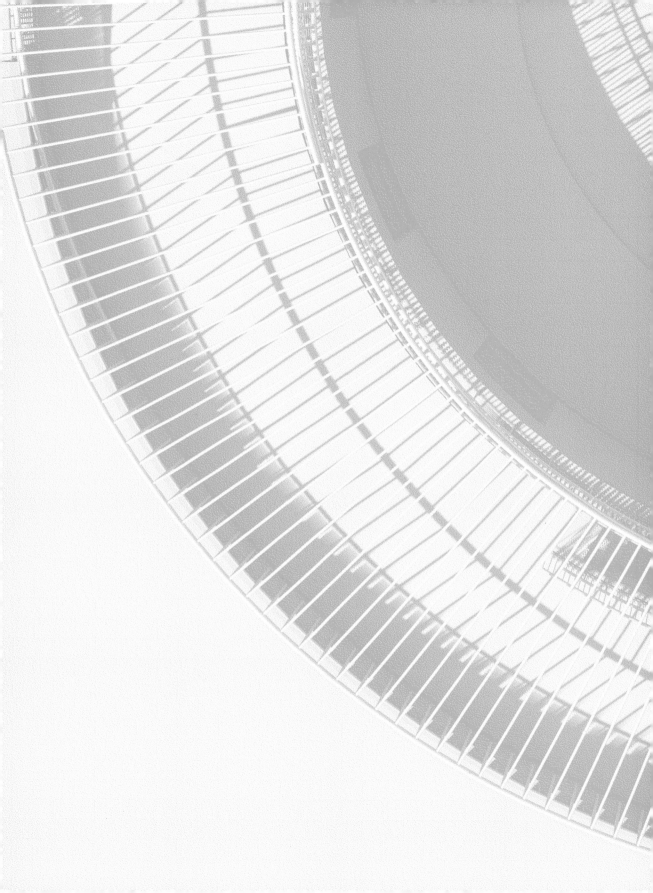

**MMCA 과천프로젝트 2022: 옥상정원
시간의 정원**
2022.6.29.–2023.6.25.

발행처	국립현대미술관
	경기도 과천시 광명로 313
	02-2188-6000
	www.mmca.go.kr
발행일	2022년 6월 27일
발행인	윤범모
편집인	송수정
제작총괄	임대근
	조장은
글	윤범모, 김찬중, 박성진,
	정연심, 배수현
	이정훈, 김이홍, 박수정&심희준,
	박희찬, 이석우
편집	배수현
편집 지원	남은혜
디자인	개미그래픽스
교정·교열	김가영
번역	서울셀렉션
사진	슈가솔트페퍼 프로덕션, 홍철기
인쇄·제책	으뜸프로세스

**MMCA Gwacheon Project 2022: Rooftop
Garden in Time**
Jun 29, 2022 – Jun 25, 2023

Published by	National Museum of Modern and Contemporary Art, Korea
	313 Gwangmyeong-ro, Gwacheon-si, Gyeonggi-do, 13829, Korea
	+82-2-2188-6000
	www.mmca.go.kr
Publishing Date	Jun 27, 2022
Publisher	Youn Bummo
Production Director	Song Sujong
Supervisors	Lim Daegeun
	Cho Jangeun
Contributors	Youn Bummo, Kim Chanjoong, Park Sungjin, Chung Yeon Shim, Bae Suhyun
	Lee Jeonghoon, Kim Leehong, Park Su-Jeong & Sim Hee-Jun, Park Heechan, Lee Sukwoo
Edited by	Bae Suhyun
Editorial Coordination	Nam Eunhye
Design	ant graphics
Copyediting	Kim Kay
Translation	Seoul Selection
Photography	sugarsaltpepper production, Hong Cheolki
Printing and Binding	Top Process Cp., Ltd

ⓒ 2022 국립현대미술관

이 책은 《MMCA 과천프로젝트 2022: 옥상정원》
(2022.6.29.–2023.6.25.)과 관련하여 발행되었습니다.

ISBN 978-89-6303-319-8

정가 20,000원

ⓒ 2022 National Museum of Modern and
Contemporary Art, Korea

This book is published on the occasion of
MMCA Gwacheon Project 2022: Rooftop
(Jun 29, 2022 – Jun 25, 2023).

ISBN 978-89-6303-319-8

Price KRW 20,000

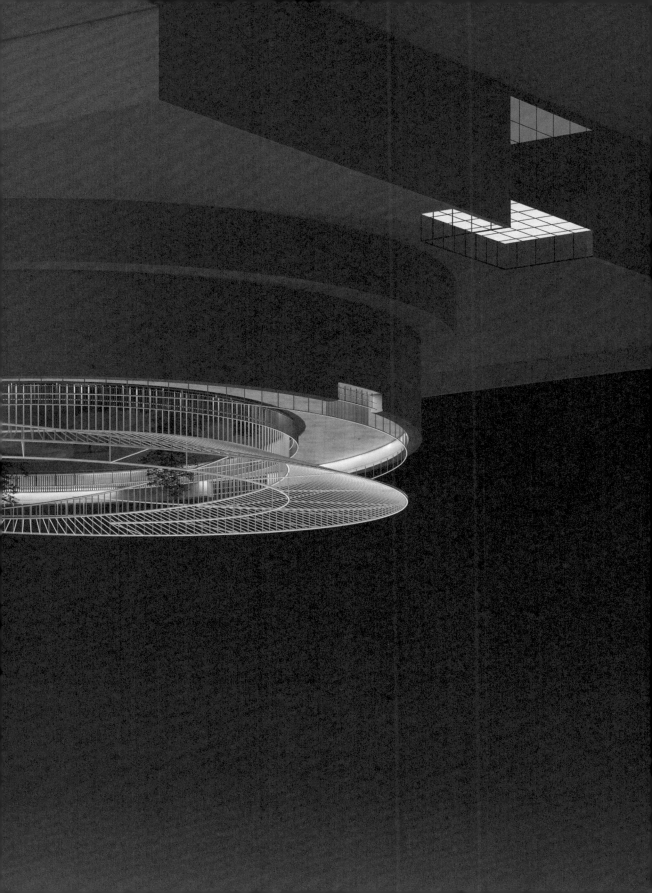

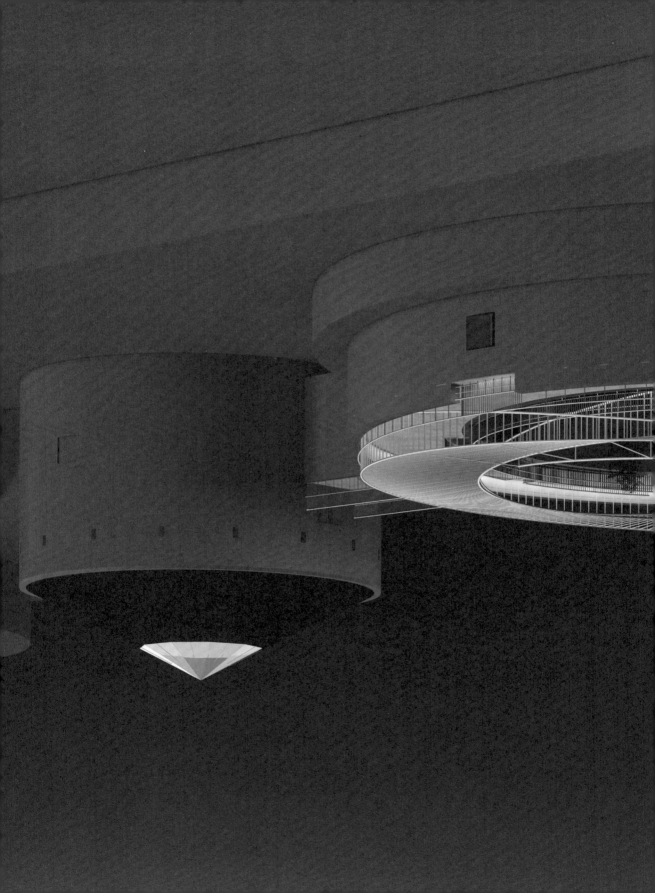

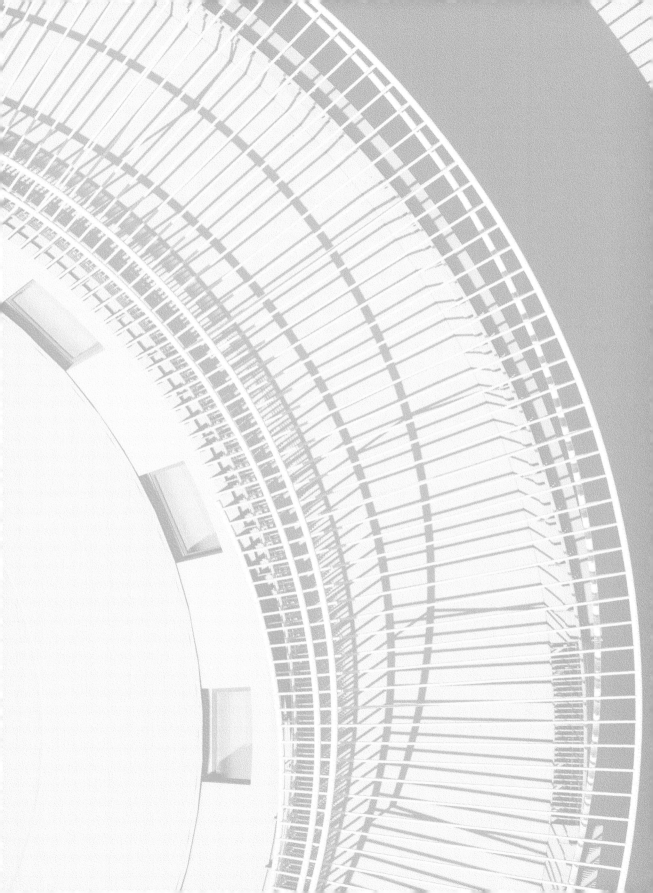